Images of America
Darien

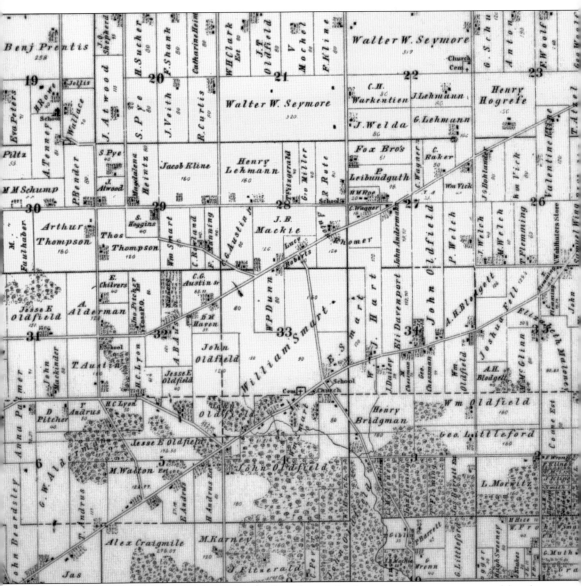

This 1874 map of Downers Grove Township shows the location of property owned by the first families in Cass and Lace. In Section 33, at the present-day intersection of Bailey Road and North Frontage Road, are the church, cemetery, and school in Cass. In Section 27, at the present-day intersection of Seventy-fifth Street and Plainfield Road, is "The Point," the center of life in Lace. (Courtesy of the Darien Historical Society.)

ON THE COVER: Dressed in their Sunday best are, from left to right, Clara, Irene, and Vera Andermann—the grandchildren of Fred and Sophie Andermann—in a field of wild daises located west of Cass Avenue and south of Seventy-fifth Street. (Courtesy of the Darien Historical Society.)

IMAGES of America
DARIEN

Darien Historical Society

ARCADIA
PUBLISHING

Copyright © 2012 by Darien Historical Society
ISBN 978-0-7385-9186-5

Published by Arcadia Publishing
Charleston, South Carolina

Printed in the United States of America

Library of Congress Control Number: 2012942217

For all general information, please contact Arcadia Publishing:
Telephone 843-853-2070
Fax 843-853-0044
E-mail sales@arcadiapublishing.com
For customer service and orders:
Toll-Free 1-888-313-2665

Visit us on the Internet at www.arcadiapublishing.com

Contents

Acknowledgments — 6
Introduction — 7
1. The Andrus Family — 11
2. First Families of Cass — 19
3. The Andermann Family — 27
4. "The Point" — 35
5. Life in Lace — 43
6. Farm Gives Way to City — 67
7. Darien Takes Shape — 99
8. Residents of Renown — 111

ACKNOWLEDGMENTS

Darien Historical Society (DHS) directors Dean Rodkin, Deborah Coulman, and Debra Kieras and DHS member Mary Krekelberg authored this book. The authors are sincerely indebted to the following individuals for their support, expertise, and contributions: John Andermann, Paul Andermann, Everett Andrus, Sturlene Arnold, Alice Brennan, Joel Dedic, Richard Eadie, Al Francis, Janet Freund, Jim Freund, Wendy Andrus Grenman, Antoinette Guynes-Garrison, Elmer Kalny, Deborah Drew Kaska, Sam Kelley, Randall Kieras, John Klancir, Tom Krekelberg, Robert Massion, Jo Mathews, Sandra Piotrowski Chereshoff, Barbara Piotrowski Northam, William and Valerie Prueter, Judy Reedy, Mary Elizabeth Rich, LaMar Rodgers, Don Rodkin, Vickie Rounsaville-Millard, Joe and Myra Slifka, Patricia Smart Maack Ormsbee, Cathy Stramaglia Herron, and Mary Sullivan.

Some images in this volume appear courtesy of the Downers Grove Park District Museum and Downers Grove Historical Society (DGPDM and DGHS). Unless otherwise noted, all remaining images appear courtesy of the Darien Historical Society (DHS).

INTRODUCTION

The city of Darien, Illinois, was incorporated in 1969, but its history goes far back in time to the Potawatomi, Sauk, and other Native American tribes that occupied this area before the arrival of the French explorer Louis Jolliet and the Roman Catholic missionary Fr. Jacques Marquette. As Jolliet and Marquette searched for a water route that would take them through the North American continent, their vision of a canal that would complete a water link between the Great Lakes and the Mississippi River paved the way for the settlement of the villages of Cass in the 1830s and Lace in the 1840s.

The earliest inhabitants of the area, the Potawatomi lived in cone-shaped dwellings covered with bark in villages of about 60 families often camped along a river. Each village had a chief. The men hunted and fished, while the women grew the "three sisters"—corn, beans, and squash. The lives of the Potawatomi began to change forever in 1673 when Jolliet and Marquette returned from their exploration of the Mississippi River through what would become the state of Illinois.

Sent by Governor Frontenac of New France (Canada), Jolliet and Marquette paddled their birch-bark canoes into the Fox River from the western shore of Lake Michigan in present-day Wisconsin. They portaged their canoes to the Wisconsin River and into the Mississippi River, traveling as far south as present-day Arkansas, when they realized that the Mississippi would not flow westward through the continent as they had hoped. On their return trip, they encountered the Illini Indians, who told them of a "shortcut" back to Lake Michigan. They took the Illinois River to the Des Plaines River. Where the Des Plaines turned north, they took their canoes out of the river, portaged them over what would become known as Mud Lake, put their canoes into the South Branch of the Chicago River, and went back into Lake Michigan. Jolliet and Marquette were the first to suggest a canal that would create a complete water link between the Great Lakes and the Mississippi River. That canal would become a priority for Illinois when it became a state in 1818.

Long before, however, the Native Americans and the French voyageurs cooperated in a lucrative fur trade. That began to change with the Treaty of 1763—ending the Seven Years' War, or French and Indian War, between the English and the French—and with New France passing into the hands of the British. Following the 1783 Treaty of Paris, the newly independent American nation expanded from the Appalachian Mountains to the Mississippi River. The start of the process of Indian removal began with the 1795 Treaty of Greenville following Anthony Wayne's victory over the Northwest Indian Confederacy at the Battle of Fallen Timbers in Ohio. A series of treaties ensued, resulting in Native Americans ceding more and more land. As settlers began to move west, the existence between Indians and settlers grew more tenuous. Stirred up by the British who resisted vacating the Northwest Territory as required by treaty and hoping to stop westward settlement, a band of Potawatomi attacked soldiers and civilians as they left Fort Dearborn in Chicago headed for Detroit during the War of 1812. After the attack, Fort Dearborn was burned

to the ground. The final blow that sealed the end of a Native American presence east of the Mississippi River came in 1832 with the defeat of Sauk chief Black Hawk. In 1833, thousands of Indians, traders, government officials, land speculators, and others gathered in Chicago as the Potawatomi agreed to the Treaty of Chicago and gave up the last of their land in Illinois, agreeing to move west of the Mississippi within three years.

The glaciers that had once covered Illinois give the state its fertile soil, and as the last ice had receded, it left in its wake the waterways that would be major factors in the growth of the state's population and commerce. Jolliet's vision of a canal linking the Great Lakes with the Mississippi River took the first step toward reality in 1822 when Congress gave Illinois the land to dig the canal. This land was included in the territory that was ceded to the federal government in a treaty with the Ottawa, Chippewa, and Potawatomi Native Americans that was signed in 1816. A second land grant gave the state five miles of land on either side of the proposed canal to sell in order to finance construction. Land in the canal corridor sold for $1.25 an acre. The towns of Chicago and Ottawa were platted in 1830. The ground-breaking ceremony for the canal took place on July 4, 1836. The state's financial difficulties caused a halt in construction, but work resumed in 1845. On April 15, 1848, the Illinois and Michigan Canal opened with the arrival of the *General Fry* in Chicago. On April 23, 1848, the *General Thornton* carrying New Orleans sugar bound for New York arrived in Chicago, having been pulled from LaSalle through the 96-mile canal by mules that were led by boys along a towpath.

Enacted into law by Congress, the 1785 Land Ordinance set up a system for settling the Northwest Territory, the land north of the Ohio River and east of the Mississippi River. Illinois would become one of five states carved out of the Northwest Territory. The land was to be surveyed and divided into townships. Each township would consist of 36 one-square-mile sections. Each section contained 640 acres.

As settlers moved west, land ownership became complicated. Many early settlers were in fact squatters who simply claimed the land by marking the trees and plowing a furrow around the perimeter of their land. Stories about the fertile soil of the prairie told by soldiers returning east after the Black Hawk War led to an influx of not only settlers but also land speculators planning to claim the land and sell it for profit. Claim jumping was rampant. Companies such as the Land Pirate Company not only marked the trees within the original settlers' borders but also set up fences. Since it was over a day's ride to get help from the county seat in Chicago, settlers took matters into their own hands and formed the Big Wood Claim Protecting Society. By 1845, the federal government had surveyed the land and claimants were able to actually purchase their land. Most early settlers purchased both government and canal land.

The Cass and Lace communities grew in Downers Grove Township in the southeastern corner of DuPage County, Illinois. DuPage County was separated from Cook County in 1839 by an act of the Illinois legislature. The county takes its name from the DuPage River, whose name comes from DuPahze, a French fur trapper who traded at a spot near where the two branches of the river meet. The name *Downers Grove* comes from Pierce Downer, the first settler in Downers Grove. The Erie Canal in upstate New York, linking the Hudson River with Lake Erie, opened in 1825, which was 23 years before the Illinois and Michigan Canal opened. The Erie Canal connected travelers from the East with the Great Lakes and became the route settlers took to reach the Midwest. Such was the case of one of the first settlers in Cass, Thomas Andrus. Along with the Andrus family, Cass residents included the Smarts, Oldfields, and Heartts.

The Lace community grew north of the Cass community. It was centered at the intersection of present-day Cass Avenue and Seventy-fifth Street. Among the first families of Lace, the Andermanns and the Buschmanns were immigrants from Germany. Joining these families in Lace were the Wehrmeisters, Warkentiens, and Prueters.

Individuals who settled in Cass and Lace earned their living farming the land and raising livestock and were involved in local government. Faith played a significant role in the lives of Lace and Cass families. Both communities established churches and cemeteries. William Smart, one of the early arrivals in Cass, established the half-acre of ground that is the Cass Cemetery.

William made part of his farm a graveyard when his infant son died in 1839. Every family within a 2.5-mile radius of his farm was given six gravesites as a gift.

Divided by different backgrounds, religions, and languages, the villages of Cass and Lace had little in common with each other. Over time, the people of Cass grew closer to Lemont. Gradually, the name *Cass* began to disappear, while the name *Lace* remained on local maps.

Education remained a priority in both Cass and Lace. Lace School was built in 1859, burned in 1924, and was rebuilt in 1925. School enrollment varied; eight pupils were enrolled in the 1945–1946 school year, while 40 students were enrolled in the 1947–1948 school year. By the start of the 1960s, enrollment in the Lace–Marion Hills School District had risen to 557. Darien includes School Districts Nos. 61, 63, and 66.

In the aftermath of technological improvements generated by the needs of World War II, people were able to afford automobiles, which meant they did not necessarily have to live close to where they worked. That fact, along with improved roads and a desire on the part of people to move out of the city, paved the way for the growth of suburbs. As people began to move west from Chicago, Lace farmers, tired of the struggle to keep their farms profitable, took advantage of the opportunity to sell their land to developers to be divided into homesites. The homes of Marion Hills, Plainfield Highlands, Clarefield, Brookhaven, Hinsbrook, and Knottingham began to transform rural Lace.

As the nature of Lace began to change, so did its churches. St. John Lutheran Church was established first, and in keeping with the heritage of the residents, services were in German. Marion Hills Bible Church was built in the 1950s, and St. Mary's Church (now Our Lady of Peace) began in 1963. As the 1960s came to an end, plans were underway for a new Catholic parish along Interstate 55 and Cass Avenue. Our Lady of Mount Carmel held its first Mass in the rented Cass School gymnasium in September 1970. Lord of Life Lutheran Church held its first service in September 1968 at Gower West School and broke ground for its present location on Seventy-fifth Street in 1971.

Two very successful men, one a politician and the other an industrialist, established summer homes in the area. Congressman Martin Barnaby Madden served in the House of Representatives of the US Congress in the early part of the 20th century. Among his many legislative accomplishments, he championed causes remarkable for the time, including the hiring of blacks by the Post Office Department and support for antilynching laws. Paraphrasing from his funeral service, it was said that the words *narrowness* and *bigotry* never entered his mind.

In May 1959, the Catholic Carmelite Order purchased Madden's summer home, Castle Eden, to create a replica of Aylesford, a Carmelite monastery near London, England. However, no funds were available to create a body of water on the grounds to make the property similar to England's Aylesford, which fronts on the Medway River. Problem solved: In exchange for selling fill to the State of Illinois for the construction of an overpass on I-55, the state agreed to build Aylesford an artificial lake. The project turned golden when the diggers discovered a natural spring that filled the lake. Today, the Carmelite Spiritual Center, formerly known as Aylesford, and the National Shrine of St. Therese are part of the Carmelite campus.

Erwin and Rosalind Freund built their estate on property that is now the home of Argonne National Laboratory. They named their magnificent property Tulgey Wood after the words that Lewis Carroll uses to describe the realm of the Jabberwock in *Through the Looking-Glass*. Freund's success stemmed from research he sponsored to find a substitute for a natural casing for sausages and other foods. An entrepreneur who valued his employees, Freund provided them with health insurance, short-term disability, and a pension plan. They did not lose their jobs during the Great Depression. Freund described his Tulgey Wood as "a part of me in which I have spent countless hours of dreams."

The road to incorporation began in 1968. Incorporation is a legal process prescribed by the state, calling for petitions, applications, minimum geographic requirements, minimum population requirements, public hearings, and public elections, with all procedures filed and documented in a court of law at the county level. Once the decision was made to pursue incorporation, the

Combined Homeowners Committee for Incorporation followed these steps resulting in the passage of the vote to incorporate held in December 1969. Called to order by chairman Del Hayenga, the final meeting of the Combined Homeowners Association Committee for Incorporation took place on May 6, 1970. The motion to adjourn the meeting was made by Gene Kolling and seconded by Robert Kampwirth. The motion carried. The minutes read, "So after 21 months (of) meetings, the Combined Homeowners Committee for Incorporation came to an end. Birth History of Darien, September 1968 – May 1970."

Two slates of candidates were nominated in the first election of Darien city officials. The Combined Homeowners Committee for Incorporation proposed one, and the United Neighborhoods Organization proposed the other. The first elected city officials served a one-year term.

May 23, 1974, was the date of incorporation for the Darien Historical Society. The following were charter members: Stanley and Nina Baker, F. Willis and Barbara Caruso, Charles and ? Hines, LaMar and Patricia Rodgers, Richard and Anita Simester, Lee and Joyce Stahl, Robert and Gerry Stevens, George and Barbara Tikalsky, the Darien Woman's Club, and the Hinsbrook Newcomers Club.

One

THE ANDRUS FAMILY

Thomas Andrus, the patriarch of the Andrus family, was born in 1801 in Wallingford, Rutland County, Vermont. He arrived in Chicago in 1833 where he was first hired to drive a team of oxen. A skilled carpenter, Thomas was then hired to help build the first Tremont House hotel, a three-story wooden building at the northwest corner of Lake and Dearborn Streets in Chicago. According to some accounts, it was Thomas who suggested the name *Tremont House* after the Boston hotel of the same name. In 1834, he worked driving piles for John H. Kinzie's grain storage warehouse, also in Chicago.

Thomas returned to Vermont, where he married Melissa Snow Bartlett in 1835. Melissa had a son, Horace, from her first marriage. Thomas had two daughters, Mary and Elizabeth, from his first marriage to Philena Fox. In 1835, Thomas purchased a little over 100 acres of land in Section 6 of Downers Grove Township. He also obtained an additional 50 acres at what is now the southwest corner of Eighty-seventh Street and Lemont Road.

Shortly after Thomas's arrival, an election was held for justice of the peace. He lost the election to his opponent, Shadrac Harris, by one vote. Thomas had two votes; Shadrac had three. However, in the next election for the same position, Thomas beat Shadrac.

As its first postmaster, most likely, Thomas named the community Cass, in all probability referencing Lewis Cass who, as secretary of war under Pres. Andrew Jackson, oversaw the conduct of the Black Hawk War and appointed the commissioners who negotiated the 1833 Treaty of Chicago.

Thomas kept horses for the stagecoach line and also raised horses for the military. Horseback mail riders supplied post offices that were not along the stagecoach line from his office. Thomas and Melissa had three sons of their own—Edgar, Charles, and Elbridge. Along with one of his sons, Thomas continued to farm until he died in 1888.

The names of many of the first families are still seen and heard. Andrus Road, named for the Andrus family, is a part of Darien, and Andrus family descendants still live in the area.

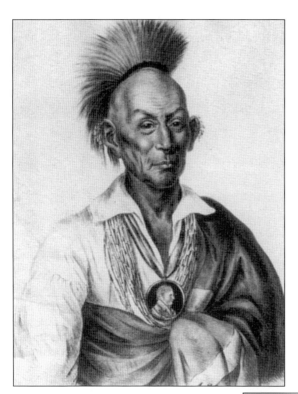

Sauk chief Black Hawk's defeat by the US Army at the Battle of Bad Axe River in Wisconsin in 1832 led to the removal of Native Americans to west of the Mississippi River and paved the way for settlement of the area.

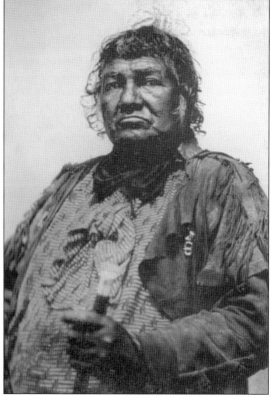

Potawatomi chief Shabbona, whose name meant "strong like a bear," saw the futility of further resistance to Indian removal and refused to join with Black Hawk. Instead, he warned settlers of impending danger, enabling them to flee to shelter at the rebuilt Fort Dearborn in Chicago.

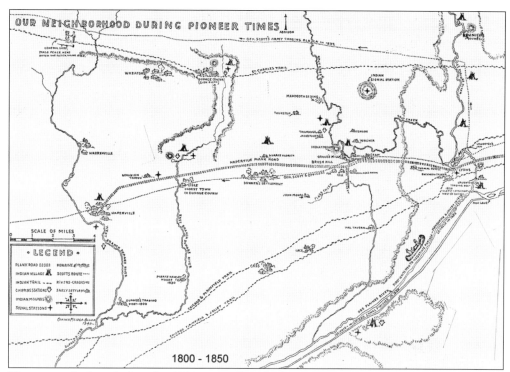

The two trails identified on this 1800 map reflect the legacy of Native Americans in the area. The Chicago and Plainfield Trail connecting Chicago to Ottawa became Plainfield Road. The Frink and Walker Stagecoach line operated along the Chicago Plainfield and Joliet Trail that would become Joliet Road, then US Route 66, and now the North Frontage Road of Interstate 55.

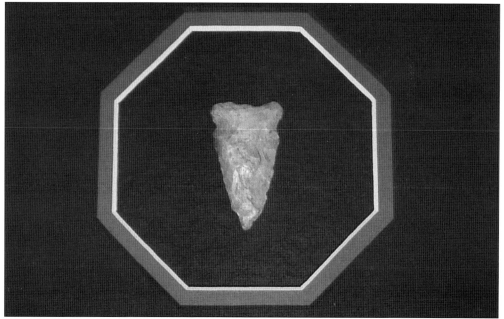

Found in 1957 on the "prairie" where Hinsdale South High School now stands, this Potawatomi arrowhead is now part of the collection of the Darien Historical Society.

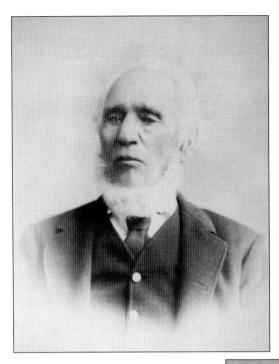

Thomas Andrus was one of the first settlers in Cass, arriving from Vermont in 1835. He was active in the political life of the community. In addition to being elected justice of the peace, Thomas was named the first postmaster of the Cass Post Office that was created in 1837, serving 15 years in this capacity. He was elected county commissioner in 1845 and was also town clerk and county assessor.

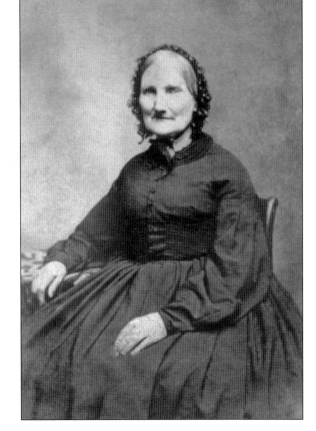

Melissa Andrus, the second wife of Thomas, married him in 1835 in Vermont. Thomas might have considered a second term as justice of the peace had not Melissa objected to participants who spit tobacco juice in the parlor of her home where trials were held.

Thomas Andrus strategically located his farm along the Frink and Walker Stagecoach line, now the North Frontage Road on the west side of Lemont Road. This prime location allowed Andrus to accommodate travelers in his home, which he used as a tavern and inn that he named Tremont House. His home also served as the first post office and as a gathering place for neighbors who attended dances in the dining room.

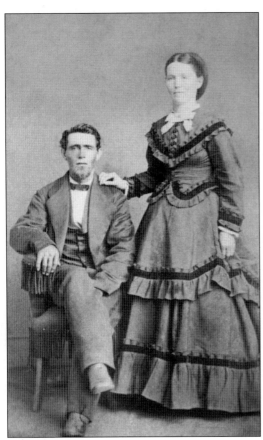

Edgar Andrus was born in 1835 and is thought to be the first white child born in Downers Grove Township. He was married in 1863 to Apthia McMillan. They had four children—Frankie, Albert, Marvin, and Phoebe. Edgar settled on his farm of 50 acres in 1867. At the age of 84 in 1919, Edgar—with shovel in hand—still appears every bit the farmer.

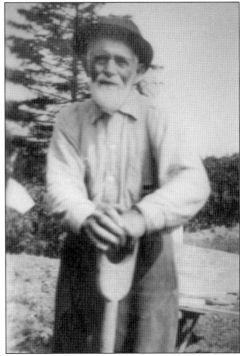

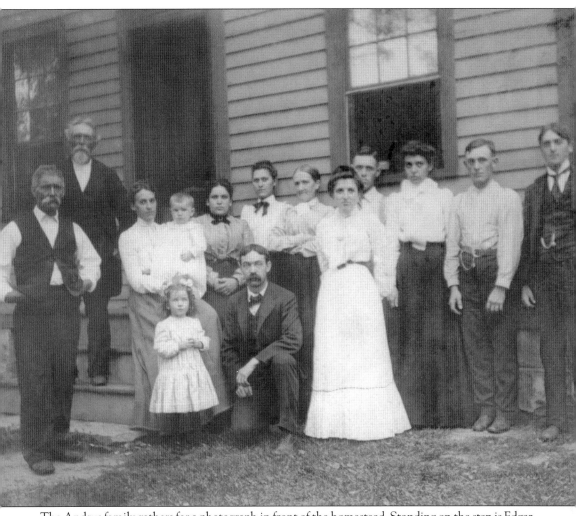

The Andrus family gathers for a photograph in front of the homestead. Standing on the step is Edgar, the first son of Thomas and Melissa. In front of him on the left is Elbridge, their third son.

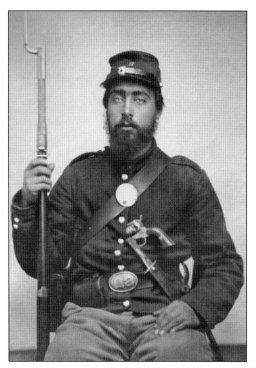

Proudly wearing his Civil War uniform, Charles, the second son of Thomas and Melissa, was born in 1837. Charles joined Company B, 33rd Illinois Volunteer Infantry, and fought in the Civil War. He saw action at Vicksburg, where the 33rd Illinois played a major role in the Union victory. Charles and Lucina had four children—Nellie, Frank, Abbie, and Roy.

Frank Palmer Andrus was the second of four children born to Lucina and Charles Andrus. This picture was probably taken on a Sunday because Frank is wearing a suit, but he still is in his element as a farmer as he poses in front of a shock of corn.

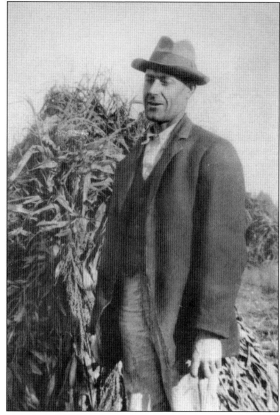

Two

First Families of Cass

Elisha Smart, one of 13 children, was born in England in 1816. Elisha, his wife, Eliza, and his father-in-law, Joshua Fell, arrived in Chicago from upstate New York in 1838. The journey took them four weeks. Elisha and Joshua worked for William B. Ogden, who sent them to DuPage County to split rails for his railroad. They earned $3 per 100 rails, which enabled them to purchase land in Cass. Elisha supplemented his farm income by transporting goods for local merchants to Chicago and by providing meat for Illinois and Michigan Canal workers. He farmed until his death in 1902. Elisha and Eliza had 10 children, eight of whom survived to adulthood. Their son Wesley served in Company B, 33rd Illinois Volunteer Infantry, during the American Civil War.

Elisha and his brother William were respected members of the Cass community. Members of the Cass Methodist Episcopal congregation, Elisha donated money and William donated the land for the church and for the cemetery.

Another prominent family, the Oldfields, also demonstrated the virtues of early settlers as they established themselves in Cass. John Oldfield, his wife, Hannah, his brother Jesse, his wife's brother James Reader, and several companions sailed aboard the *Queen Victoria* in 1845 from London to New York and then traveled to Chicago. The entire journey from England to Chicago took nine weeks. After exploring the area west of Chicago, John settled along the North Branch of the Chicago River. Three years later, in 1848, he moved to Cass. His brother Jesse came to work on his farm in 1849. Jesse married Amanda Lyon, the daughter of a local farmer, when she was 16 years old. They raised 15 children on a farm next to Amanda's parents. John and Hannah Oldfield moved to Downers Grove in 1884, leaving his daughter Libby and their son-in-law George Heartt to run the farm. After his wife died, John spent his last years with them on the farm. George and Libby Heartt sold the farm and moved to Downers Grove sometime before 1910.

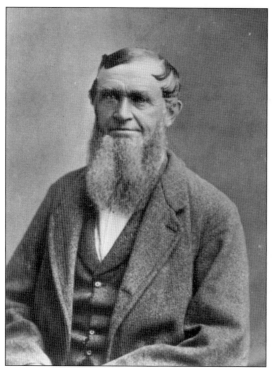

Elisha Smart moved to Cass in 1839 and purchased 50 acres of farmland at $2.50 an acre. In 1853, Elisha left for the California goldfields, where he worked until 1859, sending money home to his wife, Eliza, enabling them to purchase an additional 70 acres. She managed the farm and cared for their eight children. Wesley, the eldest son, was only 11 years old when Elisha went west.

In 1840, William, the elder brother of Elisha Smart, purchased 87 acres in Cass adjoining Elisha's farm for $800. William married Mary Fell, Eliza Smart's sister. William and Mary had five children. He became one of the largest landowners in Cass because he was frugal and a smart businessman. This sketch of his large farmhouse, outbuildings, cattle, and horses reveals his prosperity.

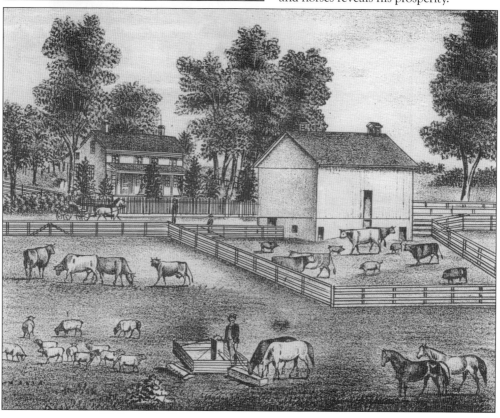

Although William's property passed through several owners, the farmhouse, built in the 1800s, survived until 1986. The Darien Historical Society made a futile attempt to preserve it. However it was demolished because the cost to repair it exceeded its value. The Smart farm buildings stood on land that now is part of the Carmelite Spiritual Center.

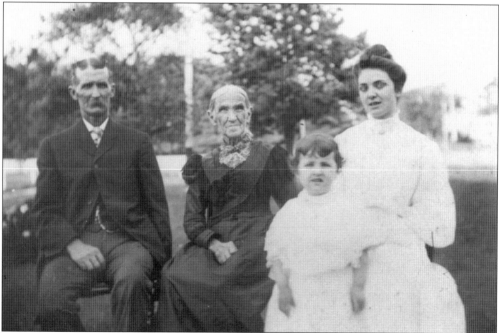

Mary Fell married successful landowner William Smart in 1839. The Smart brothers each married a Fell sister. Mary was the mother of five children and is shown here in her 90s with her fourth child, Albert. To each of their four sons, William and Mary left a farm and $10,000 in cash. (DGPDM and DGHS.)

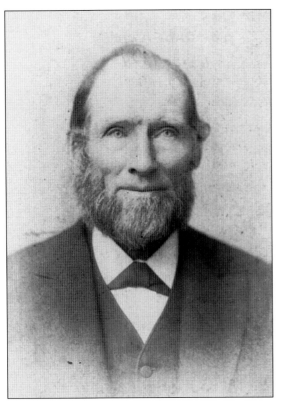

John Oldfield, a native of England, was born in 1824. It was not until about 1848 that he arrived in Cass and started out with 20 head of cattle and five horses on 40 acres of land. Year after year, he added to his purchases, eventually owning almost 2,000 acres. He was the largest contributor to the Cass Methodist Episcopal Church building fund. (DGPDM and DGHS.)

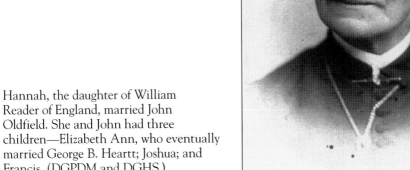

Hannah, the daughter of William Reader of England, married John Oldfield. She and John had three children—Elizabeth Ann, who eventually married George B. Heartt; Joshua; and Francis. (DGPDM and DGHS.)

Young George B. Heartt, pictured before the start of the Civil War, was the eldest of the 10 children of William and Susan Heartt. Swept up in the patriotic fervor following the firing on Fort Sumter, he answered President Lincoln's call for volunteers, and like others from Cass, he joined Company B, 33rd Illinois Volunteer Infantry. Inducted as a private, before he mustered out in 1865, he had been promoted to full corporal. (DGPDM and DGHS.)

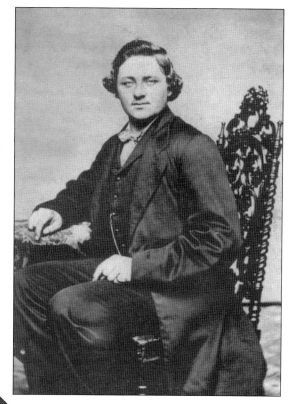

George B. Heartt married Elizabeth Oldfield in 1869 and lived with his family on the farm of John Oldfield. John and Hannah moved to Downers Grove, and George continued farming on his own in 1884. After the death of his mother-in-law, Hannah, in 1891, he welcomed John back to his home. (DGPDM and DGHS.)

John and Hannah Oldfield's only daughter, Elizabeth "Libby," married George B. Heartt in 1869. On the occasion of their 25th wedding anniversary, George had a well-worn wedding ring at the end of his watch chain. An article in a newspaper states that "it had never been removed until he replaced it with another of greater value. To all those present, it was obvious that he did not consider his marriage a failure." (DGPDM and DGHS.)

In 1834, with Thomas Andrus's help, Father Beggs, a circuit-riding minister who traveled back and forth from Plainfield, Illinois, to Chicago, established the Cass Methodist Episcopal Church on the North Frontage Road. A colorful person, Father Beggs was six feet tall and weighed over 200 pounds. According to one account, he preached so loudly that he could be heard from a distance of three blocks.

Churches were not only the home of the religious life of the community but were also the center of social activities, as indicated by this handbill. Readings, vocal solos, and piano solos made for an evening's entertainment at the Cass Methodist Episcopal Church at the cost of 25¢ for adults. Although cut off from the handbill, it is safe to conclude that there was no charge for children under 14.

Musical and Literary Entertainment

CASS M. E. CHURCH.

THURSDAY, MAY 29, 1902,
AT 8 P. M.

PROGRAM

Piano Solo	Selected
Reading	
Trouble in Amen Corner	T. C. Harbough
Im-ph-m	Thos. Nicholson
Vocal Solo "Out on the Deep"	Lohr
Reading	
John Burns of Gettysburg	Bret Harte.
Lucky Jim	Anon.
Piano Solo	Selected.
Reading	
The Welsh Classic	Ballard.
The Widow Malone	Sam'l Lover.
Vocal Solo	Selected.
Reading	
The Combat	Sir Walter Scott
The Yankee in Love.	Alfred Burnett

Pianist Miss Bertha Hardin.
Soloist Mr. Bradley Roe.
Reader Rev. T. K. Gale.

Admission, Adults 25c. - Children under 14 years,

The Cass Cemetery stands along the North Frontage Road on land donated by William Smart. It contains the graves of the early settlers of Cass and their descendants. Among those buried in the cemetery are 10 Civil War veterans who volunteered knowing that the Union was in trouble and something had to be done. Many of the cemetery's tombstones show the effects of time and weather.

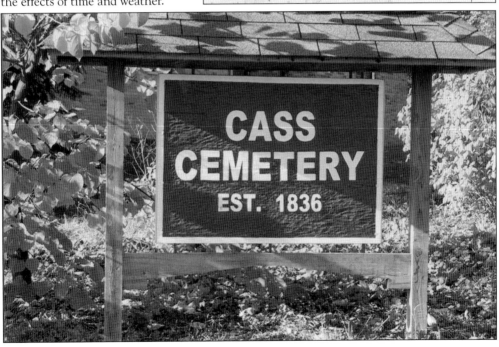

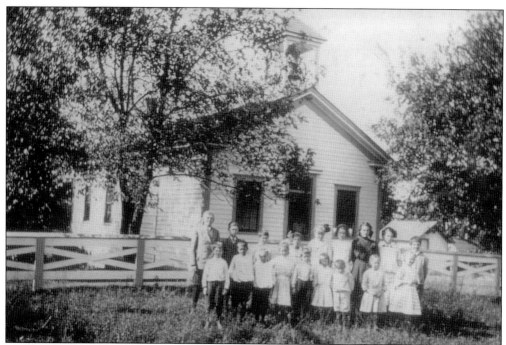

Built in the late 1800s, Cass School, located on the southeast corner of Bailey Road and the North Frontage Road, was a one-room schoolhouse that was the beginning of Cass School District No. 63. It burned down sometime in the early 1900s. At one time, there were two Cass Schools. This one was known as Upper Cass. Lower Cass was located in what is now Waterfall Glen Forest Preserve and was replaced by the schools in Community Consolidated School District No. 180.

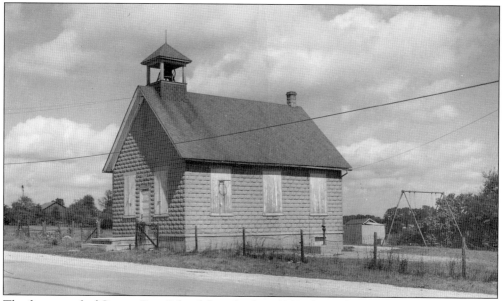

The first record of Center Cass School dates back to 1862 when, along with Cass School, it was one of four schools in the area. It burned to the ground in 1913. Reportedly, the pump in the schoolyard became so hot that it could not be used to aid the firefighters. Located at Lemont Road, south of Eighty-third Street, it was the start of School District No. 66.

Three
THE ANDERMANN FAMILY

The Andermann family played a significant role in the growth of Lace following their arrival in the 1860s. John and Dorothea Andermann and their only child, Fred, and his wife, Sophie, joined other families of German ancestry who were attracted to this area. Fred and Sophie and their eight children established a legacy of hard work and involvement in the community. In addition to property bought by his father at "The Point," Fred purchased more acreage on Clarendon Hills Road. The land was farmed and used as pasture for cattle. Fred's parents were charter members of St. John Lutheran Church.

After the death of his parents, Fred inherited the farm, and he and Sophie continued to reside in the farmhouse. Their children were born within a span of 17 years, from 1867 to 1884. The farmhouse, similar to others of the same period, was made of wood. Dormers were added as the family grew and provided rooms for the hired hands. Instead of closets, rooms offered wardrobes. The kitchen had a wood-burning cast-iron stove with a metal smokestack that went up through the walls. Fire in the stove was used to heat water and to provide heat for the kitchen. Everyone entered through the closed-in porch in the back of the house, where they would leave boots and outer gear. The parlor was closed off during the week. It would be cleaned on Saturday and set up for Sunday dinner, when everyone wore his or her Sunday best. Traditionally, for families of German heritage, the parlor doors would be opened on Christmas Eve to reveal the splendor of the tree aglow with lit candles.

Fred and Sophie had a large orchard and a vineyard that produced enough grapes to make more than one barrel of homemade wine. Grandchildren remember putting on boots and stomping around in a washtub filled with grapes to smash them for straining.

Six of the Andermann children stayed in Lace. The home John built still stands on Clarendon Hills Road and is over 100 years old. Mary married Charles Knapp and moved to Chicago, where he worked in the Union Stock Yards. Henry moved to Hinsdale. Fred Jr. and Emma never married, stayed on the farm, and continued the traditions of Fred and Sophie.

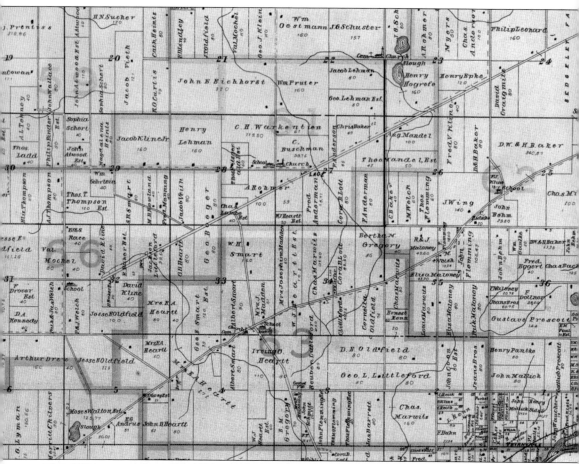

This 1904 map updates the 1874 map (on page two) of land ownership in the Cass and Lace communities. By 1884, Lace's population was around 500 people. New family names, including Andermann, Buschmann, Warkentien, Lehmann, Veith, and Klein, are testimony to the population growth of Lace.

The patriarch of the Andermann family, Fred, was born in 1843 in Hanover, Germany. An only child, he emigrated in 1854 with his parents, John and Dorothea, who first settled in Proviso Township in Cook County where they farmed for 10 years. In 1864, the family bought an 80-acre farm in Lace for $25 an acre. In addition to farming, Fred held public office and was secretary of the Downers Grove Farmers Mutual Insurance Company.

Sophie, Fred's wife, was also from Germany. They met and married in Proviso Township. The extended Andermann family had an open invitation to come for dinner every Sunday after church. Her grandchildren loved that she always had cookies. A favorite spot for them was to sit on a footstool at her feet, while she listened attentively to what they had to say as she sat in her rocking chair, wrapped in a shawl, crocheting or knitting.

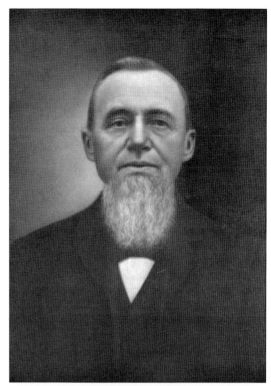

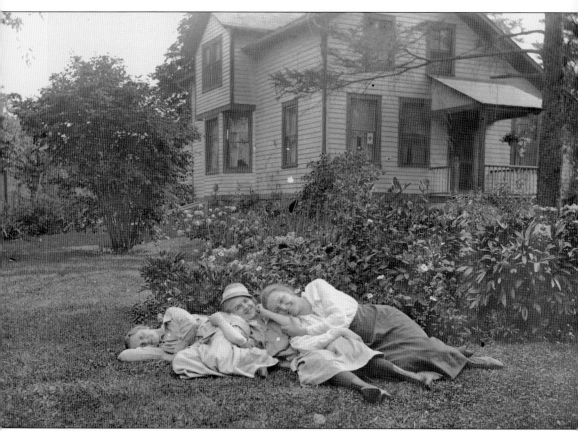

On Plainfield Road, the Andermann farm was located directly south of The Point. At the time, Seventy-fifth Street dead-ended at the driveway, which was lined with 100-year-old elm trees that led to the farmyard. The farmhouse on the property faced north. Fred added the dormer and the bay window on the east side and the porch on the north side to the original house that dated back to the mid-1800s. Relaxing on the lawn are, from left to right, Vera, Clara, and Irene Andermann.

Standing along the back (south) of the Andermann farmhouse are, from left to right, Emma, John Sr., and Fred Jr. To Fred's right is the smokehouse where hams were smoked and bacon was cured. Fred Sr. built the dormer on the back to add more bedrooms and also the back porch. The door on the right, used only on Sundays, was the entrance to the parlor.

Irene stands in front of Sophie's flower garden east of the house outside the bay window. Sophie took humble pride in her garden, which included hollyhocks, rose bushes, peonies, and irises along with a fishpond and a rock garden. Unusual for the late 1800s, Sophie was able to find time for her garden while keeping up with her household responsibilities.

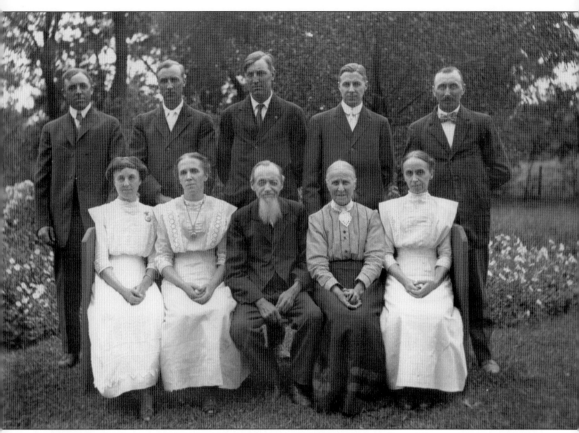

Photographed around 1906 are Fred and Sophie's children. From left to right are (first row) Emma, Mary, Fred Sr., Sophie, and Louisa; (second row) Edward, Fred Jr., John, Henry, and William. They are pictured facing east in birth order in the front yard of the farmhouse on a bench that was taken out of the parlor.

After a lengthy courtship, John Andermann and Alice Buschmann were married on July 30, 1910. Alice was the daughter of Conrad and Sophie Buschmann. Conrad owned the creamery. John and Alice's marriage united two of the families who contributed greatly to Lace's prosperity. Alice's love letters survive along with doll dresses that were made from her wedding dress.

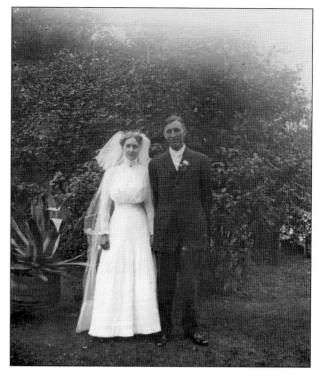

Minus the women, the men gather for a smoke on the south side of the smokehouse following John's wedding ceremony. From left to right are (first row) unidentified, Edward, and unidentified; (second row) Fred Sr., Rev. Martin Nickel of St. John Lutheran Church, unidentified, Ed Baethke, John, Fred Jr., and Walter Wehrmeister.

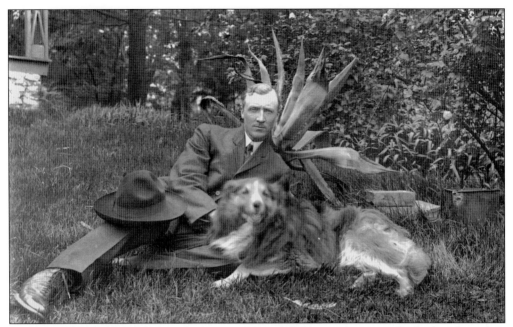

Fred Jr. and his dog Rex relax on the lawn in front of the agave plant near Sophie's rock garden. Fred never married despite secret admirers, many of whom sent him anonymous valentines. He was a very generous uncle to his many nieces and nephews.

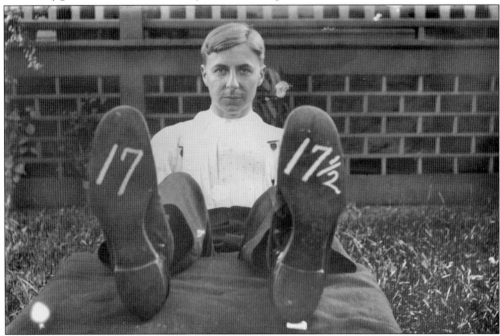

Henry's sense of humor is apparent as he shows off his unusually large feet. His expertise with a view camera as an amateur photographer became apparent when the Darien Historical Society received his collection of photographs made from his glass negatives. Eventually moving off the farm and establishing a successful laundry in Hinsdale, he continued to use his extended family for the subjects of his photographs.

Four
"The Point"

More than one explanation exists for the origin of the name *Lace*. The one with the most provenance is that John J. Keig named it Lace (as explained in the caption of his picture on page 36).

However, some say the name originated from an Anglicized way of saying Alsace-Lorraine, a disputed area between Germany and France, from which many of the first to arrive in Lace came. Ownership of a store passed from John Keig to Jacob Lehmann. Local lore has it that Fred Gansburg, who purchased the general store from Lehmann, when asked for the name of the community by the Post Office Department, looked up at a bolt of lace on a shelf, or at lace curtains on the window, and said to call it Lace.

Whatever the origin of the name, the triangle of land bordered by Cass Avenue on the west, Plainfield Road on the south, and Seventy-fifth Street on the north, known as "The Point," served the needs of the Lace community. In addition to dances, Lace Hall was home to a raffle for live turkeys that was held the Saturday before Thanksgiving. Tickets were sold for 25¢ each. One year, the price was raised to 50¢, but that brought too many complaints. With the loss of Lace Hall, the raffle continued to be held in a Quonset hut toolshed on the same property. Every machine was taken out of the toolshed for the raffle, and dressed birds were raffled off instead of live ones. The last raffle was held in 1955.

Conrad Buschmann's creamery served the needs of the Lace farmers who raised dairy cattle. Conrad dug out a low spot in his pasture and created a pond to harvest ice in the winter for the creamery. Children who ice-skated on the pond had to first ask if the bull was in the pasture. Results could have been disastrous if he had been there. The former pond is now a part of Jewel Osco's parking lot.

The Point was the focal point of the Lace community for many years, and the name remains in use in Darien. A McDonald's restaurant now occupies the spot where the Buschmann creamery once stood.

John J. Keig, born in 1858 on the Isle of Man, immigrated in 1883 to Chicago. He opened a store in DuPage County in 1884, expanded his business, and established a post office. When asked how to identify the area by the federal government for postal delivery, he chose the name *Lace*, which was his mother's maiden name.

Ann Lace Keig was born in 1828 and died in 1911. Although she remained in England, she left her worldly possessions to all her children except John, who was very successful in his own right. John must have been very fond of her to name the community Lace.

In the 1880s, The Point consisted of the buildings shown on the map. The dotted lines on the map indicate the Fred Andermann farm and the Conrad Buschmann farm. Seventy-fifth Street did not extend beyond Plainfield Road. The Point was the center of community life in Lace.

In this view looking south toward Seventy-fifth Street, the Buschmann farmhouse is on the far left, located about a 400-foot walk from the barn. To the left of the pasture is the icehouse. Between the icehouse and the back of the church was the William Wehrmeister farmstead that stood on the north side of Plainfield Road.

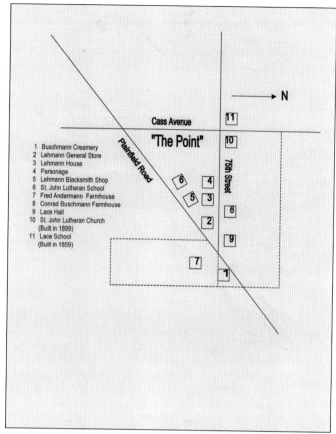

1 Buschmann Creamery
2 Lehmann General Store
3 Lehmann House
4 Parsonage
5 Lehmann Blacksmith Shop
6 St. John Lutheran School
7 Fred Andermann Farmhouse
8 Conrad Buschmann Farmhouse
9 Lace Hall
10 St. John Lutheran Church
 (Built in 1899)
11 Lace School
 (Built in 1859)

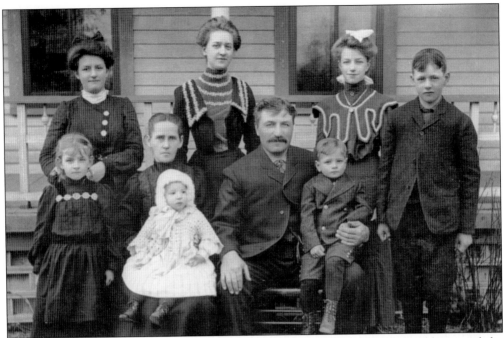

Like others his age, Conrad Buschmann left Germany when he was 19 years old to avoid the Kaiser's army. He came through Ellis Island in 1874 and was offered a job by a man from Downers Grove. He worked as laborer, saved his money, and brought his family here from Germany. Family members, from left to right, are (first row) Laura, Sophie holding Esther, Conrad, Arnold, and Albert; (second row) Malinda "Lindy," Alice, and Amanda "Mandy."

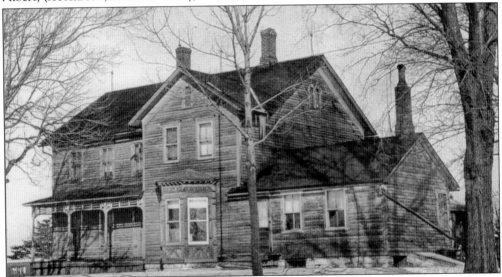

The Buschmann house was about half a block west of The Point on the north side of Seventy-fifth Street. The design and the decor of the house reflected Conrad's success. Thought of as a mansion, it had a beautiful open front staircase that was hand carved in Germany. The back staircase was used by the family's hired hands and led to the rooms where they slept. The section of the home without a second story was the kitchen, where the family entered the residence. The house stood until 1966, when it was razed for the building of Hinsbrook homes.

Conrad established the creamery in the mid-1880s. Daily, farmers brought their milk to the creamery immediately after the morning milking. In those days, milk was not pasteurized. Milk, butter, and cheese from the creamery would be taken by hired hands to Chicago on a horse-pulled wagon—a day's journey.

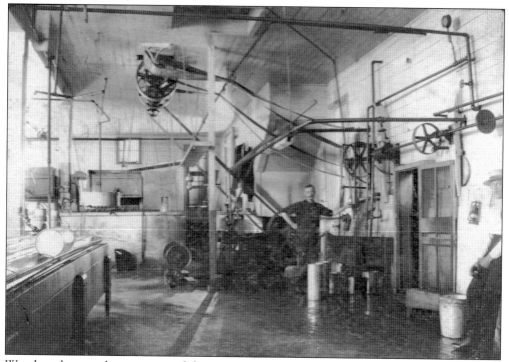

Wooden cheese tubs were part of the creamery equipment. The walls were whitewashed for sanitation. New federal laws changed processing requirements that led to less profit. When the Burlington Northern Railroad came through Greggs (now Westmont), it was cheaper for farmers to send their milk directly to Chicago by train. In 1904, Conrad closed the creamery, and soon after, it burned. After selling the farm to Fred Wehrmeister, Conrad's family moved to Russell, Illinois, in 1906.

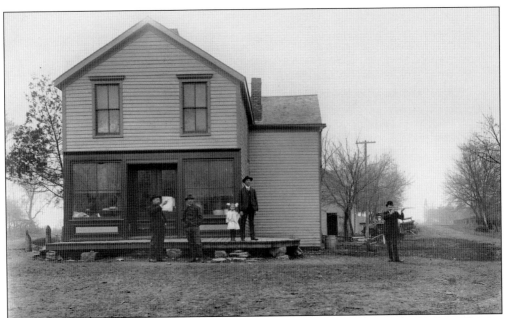

Jacob Lehmann Sr. was born in 1828 in Alsace-Lorraine, France, and arrived in DuPage County in 1857. Later, he became the owner of the general store that stood at the "tip" of The Point. The store was also home to the post office. Residents would often run a tab for the purchase of things that they could not produce themselves, such as tools, fabrics, and dry goods. The general store was a great place to socialize.

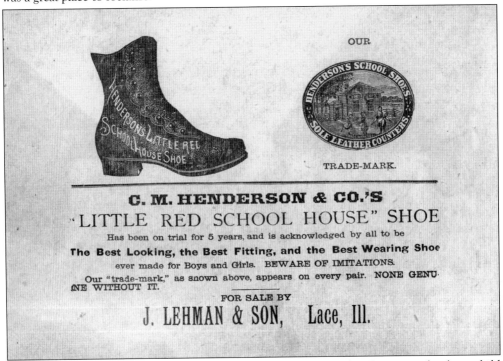

This advertisement claims C.M. Henderson & Co.'s shoes are perfect for every school-age child and are among many items available for purchase at the Lehmann store.

Not long after the creamery burned, the general store also burned. That was the beginning of the end of Lace because, in 1910, postal service was transferred to Hinsdale. To the west of the burned out foundation of the store is Jacob Lehmann Jr.'s blacksmith shop, facing Plainfield Road, where the horse and buggy stand. St. John Lutheran School was west of the blacksmith shop, facing Plainfield Road. Completing The Point were the Lehmann house and the parsonage west of the store and facing Seventy-fifth Street.

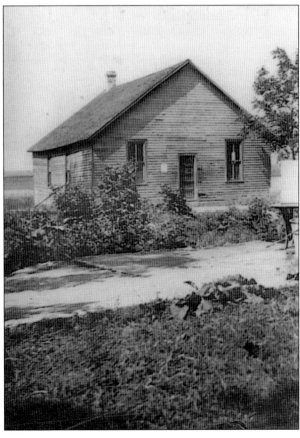

Built in the late 1880s on the Buschmann farm, Lace Hall was the social center of the community. Admission to the popular ballroom dances was 75¢ a person. Musicians were paid $10 or $15 for the night and were met with horse and buggy at Greggs's railroad station. After a bad windstorm blew the building over, it was declared unsafe and torn down.

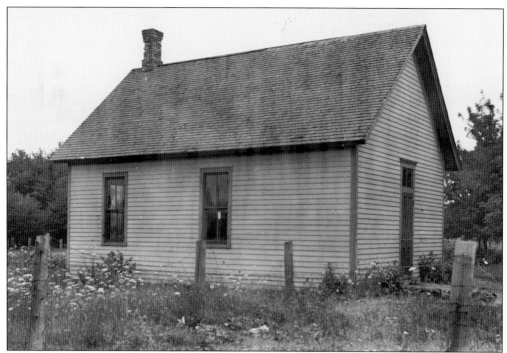

St. John Lutheran School was built in 1894 originally for instruction on Saturdays and in the summer months. It became a Christian Day School in 1906 with 25 students. All eight grades were taught in German by Rev. Martin Nickel. Children walked to and from school and brought their lunches. After school, kids had to hurry home for their farm chores. The school existed at this location until the early 1920s.

The parsonage at The Point was built in 1893. Rev. Martin Nickel lived in the house. When Seventy-fifth Street was extended from The Point to Route 83 in 1957, the parsonage was sold and moved to its present location on Clarendon Hills Road.

Five

LIFE IN LACE

Life in Lace in the first half of the 20th century centered on family, church, and school. Livelihoods depended on farming, raising crops, and animals. Farmers expanded acreage as children grew up and continued to follow in the footsteps of their parents. Farm work became mechanized. Lace prospered as a community of people invested in one another's welfare. People worked together, looked out for each other, and thrived in an environment filled with a sense of belonging and trust.

Before she was married, Frances Morgan Eichhorst taught at the first Lace School from 1914 to 1916. She graduated from high school, took a test to become a certified teacher, and was hired—never having attended college. Because she lived in Downers Grove, she would hire a rig at the livery for $1 to take her to school on Monday and stay with the Rohmer family during the week, paying them $14 a month for room and board. Her salary was $35 a month. She taught reading, arithmetic, geography, history, penmanship, and spelling.

No government resided in Lace. Conrad Buschmann was the justice of the peace. Anything legal would require a trip to the county seat in Wheaton. Three rural mail routes extended from the Hinsdale Post Office. Police protection was provided by the DuPage County Sheriff's Office. Many of the homes were on well water. Families banked in Downers Grove or in Hinsdale.

Every farmer in Lace had dairy and/or beef cattle and hogs. Hogs would be hauled to the Union Stock Yards in Chicago and sold through a broker. To feed their cattle, farmers would buy malt from a brewery near the stockyards.

Simple pleasures prevailed. Malinda Andermann, whose paternal and maternal grandparents were among the first families in Lace, recalled a favorite Halloween "trick" enjoyed by Lace boys. On Halloween night, they would hoist outhouses to the rooftops of barns. The next day—in all innocence—they would tell the farmers that they would be happy to assist in removing the outhouses from their barn roofs. Many an appreciative farmer would then reward the boys for their help.

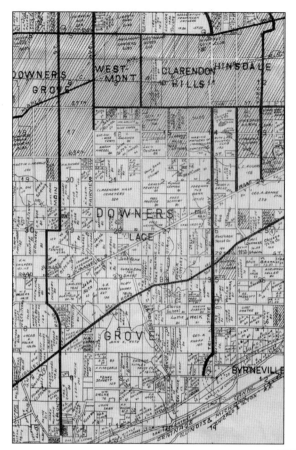

This 1943 plat map of Downers Grove Township clearly identifies Lace. By then, the Cass community no longer existed as a distinct entity. The map still includes the names of families identified in previous chapters and also shows how property changed hands over time. (Courtesy of William Prueter.)

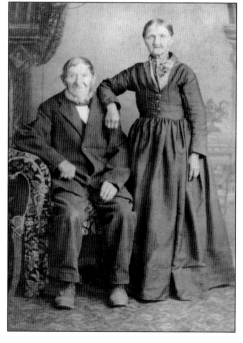

Along with others, Jacob Veith and wife, Catharina, immigrated to America in 1855 from Alsace-Lorraine, giving credibility to local lore that says language derivations of *Alsace* are the origin of the name *Lace*. His property in Section 20 of Downers Grove Township is shown on the 1874 map on page 2.

Heinrich "Harry" Lehmann and Ursula Veith, daughter of Jacob and Catharina, were married in 1863. They both came to America from Alsace-Lorraine as youngsters with their parents. Harry bought property and established a farm on Seventy-fifth Street west of Cass Avenue.

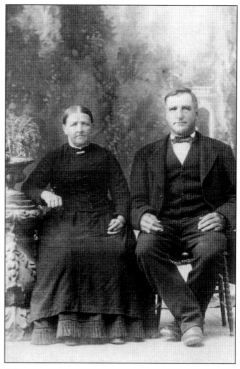

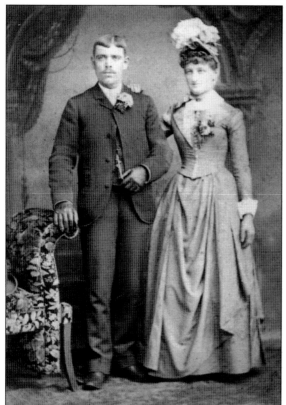

Arthur Clinton Drew was born in 1886. In 1889, he married Sarah Lehmann, the daughter of Heinrich and Ursula Lehmann, whose farm is indicated on the 1874 map on page 2. Like many farmers, he held other jobs to make ends meet and died in 1918 from injuries suffered while loading coal on a railcar in Chicago the previous year.

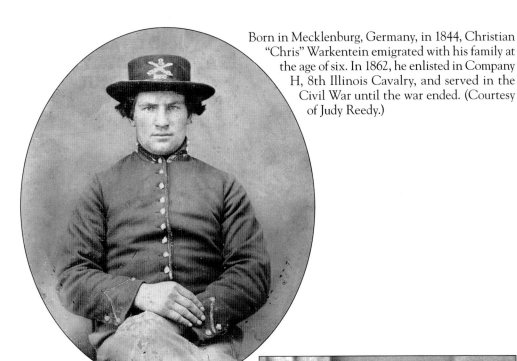

Born in Mecklenburg, Germany, in 1844, Christian "Chris" Warkentein emigrated with his family at the age of six. In 1862, he enlisted in Company H, 8th Illinois Cavalry, and served in the Civil War until the war ended. (Courtesy of Judy Reedy.)

Chris married Louisa Boeger in 1866. For 16 years, Chris served on the Board of Highway Commissioners, much of the time as treasurer. He was also president of the Farmers' Insurance Company. When he died in 1907, Rev. Martin Nickel eulogized him as "a citizen who exemplified the highest ideals of patriotism and citizenship." (Courtesy of Judy Reedy.)

Friedrich Heinrich "Fred" Hogrefe arrived in America from Germany in 1855 and built this home in 1862. One of the few remaining original homes, it still stands today on Eleanor Place in Darien. What appears to be an addition was actually a summer kitchen where cooking was done to keep heat out of the house. (Courtesy of Bobbie Norris.)

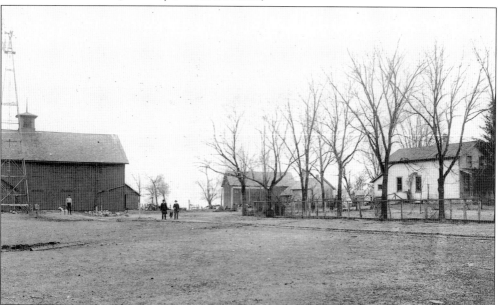

Fred's father, John Andermann, was one of the first landowners in Lace. In this image taken in the 1860s, note Fred's expansion of the farm. From left to right are the dairy and hay barn, the granary, the smokehouse, and the original Saltbox-style house.

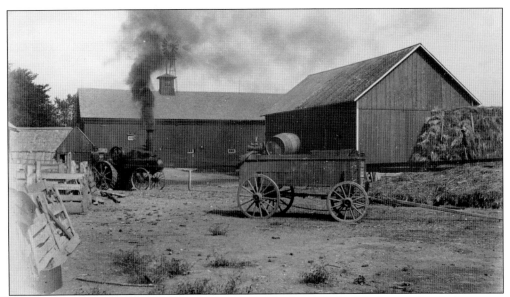

The hay and milking barn is in the background; the shed to the left of the barn is the chicken coop. Billowing smoke rises from the steam tractor, probably one of the first in the area, and illustrates the beginning of the transition from horses to machine power. Notice the flat belt coming from a pulley on the tractor that was used to power the threshing machine that is not shown.

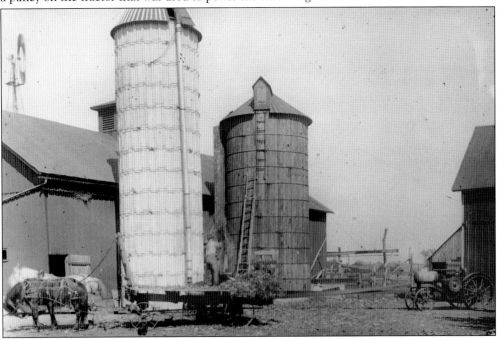

The Lace landscape was dotted with silos, in which silage, or cut green corn for animal feed, was stored. The smaller silo was constructed using 25-foot-long, two-by-six-inch tongue-and-groove pine boards. Nails were not used in the construction; adjustable steel hoops circled the silo and bound the boards. The moisture in the green corn would cause the boards to swell, making the silo airtight. The large silo was made from concrete staves; surviving silos today are most likely made this way.

A common barnyard sight would have been ducks and chickens roaming "free range." These ducks are taking advantage of their feed trough on the Prueter farm. (Courtesy of William Prueter.)

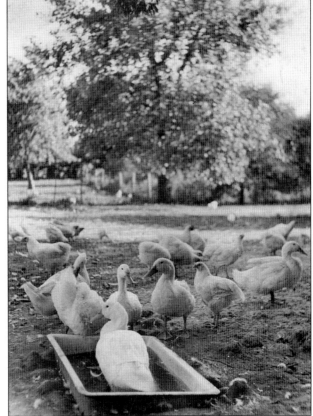

An average farm might have up to 200 chickens. Rhode Island Reds were good eating; leghorns were good layers. Surplus eggs would be sold to supplement incomes. Many a chicken found its way into the kitchen after its head was placed between two nails on a log and chopped off by the curved blade of a corn knife.

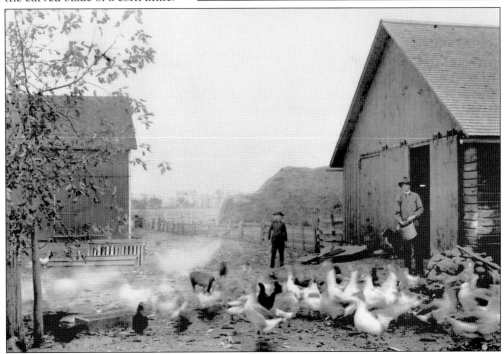

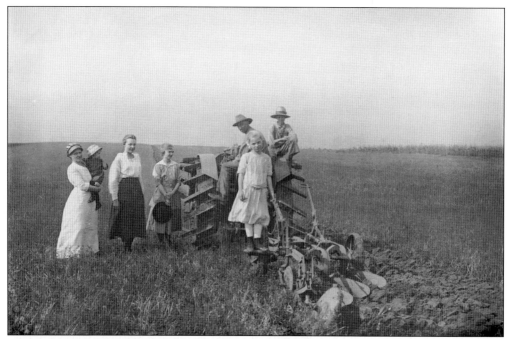

In 1910, International Harvester Company manufactured the Titan tractor. The picture leaves no doubt as to the vastness of the land devoted to farming in Lace.

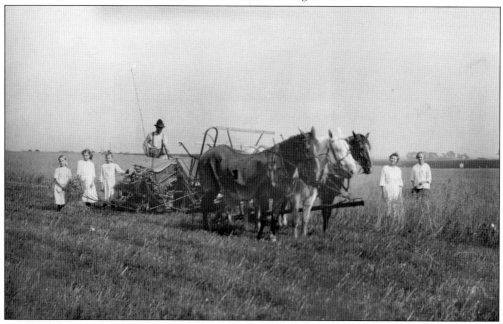

Binding oats meant cutting the oats, putting them in bundles, and then putting the bundles in shocks to allow the grain to cure. Behind the horses, there is a sickle and a canvas platform. A wooden bat reel turned and knocked the straw onto a canvas platform that turned as it carried the straw up behind the horses and put it in a bundle. A big iron needle with twine would go up and over the bundle, circling it, and then the twine would be knotted and cut. The bundles would be knocked to the ground where they would lie in rows until they were gathered.

In this image looking northeast from Fred Andermann's farm, the Buschmann creamery is in the background. The windmill was necessary to pump water for the well. The ponies still have their winter coats, indicating this is early spring. After the creamery burned, Ed and Louisa (Andermann) Baethke built a house on the property and lived there until the 1940s.

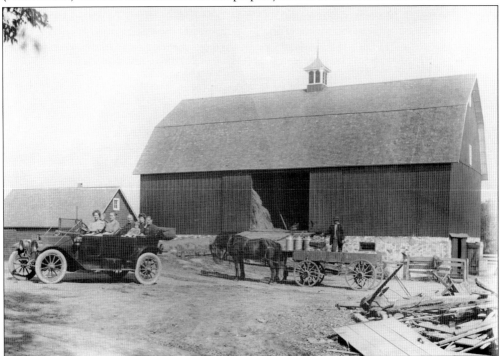

In this c. 1910 image, Conrad Buschmann's hay barn stands strong. The stone foundation contains the entrance to the basement dairy, considered very modern for the time. Once the creamery closed, the milk cans on the wagon would be taken to Greggs (Westmont) for delivery to Chicago.

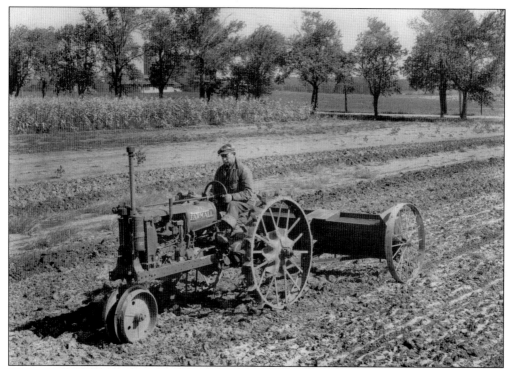

Walter Wehrmeister had an International Harvester contract to test experimental equipment like this Farmall F-10 tractor for a season, evaluate it, and then return it. Walter poses at the International Harvester farmstead located on the land from Madison Street to County Line Road. Walter took his share of teasing because he owned a yellow Case tractor with iron wheels, not an IH tractor. As a prank, IH men put rubber tires on his tractor and painted it red.

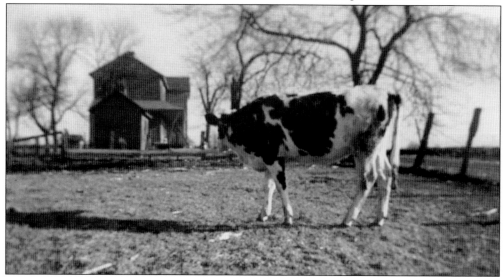

Roy and Earl Bartholomae's 4-H project was this heifer, or a female cow that has not had a calf yet and would not until she was two years old. William Wehrmeister's farm was located in The Point on land that was used as pasture and never farmed. Cows would be brought across Seventy-fifth Street after the morning milking to graze in the pasture until evening milking time.

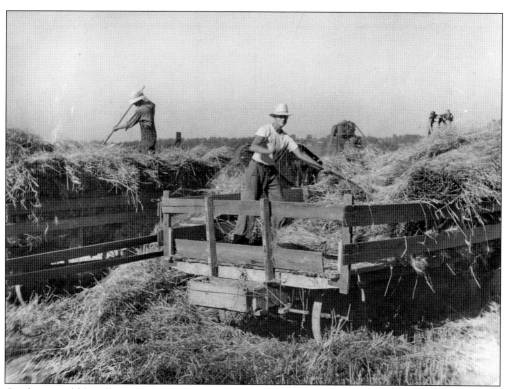

Cut hay would be allowed to dry in the field and was then raked into windrows to be picked up by the hay loaders on the Prueter farm. Loading a mixture of clover and timothy hay meant two men on a hayrack—one driving the horses and the other loading the hay with a pitchfork. (Courtesy of William Prueter.)

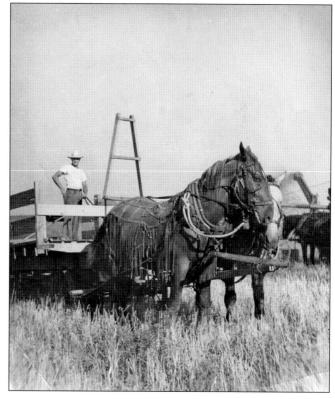

Porky and Tom were the treasured workhorses on the Prueter farm. Horses were often thought of as a part of the family and, unlike other farm animals, given names. (Courtesy of William Prueter.)

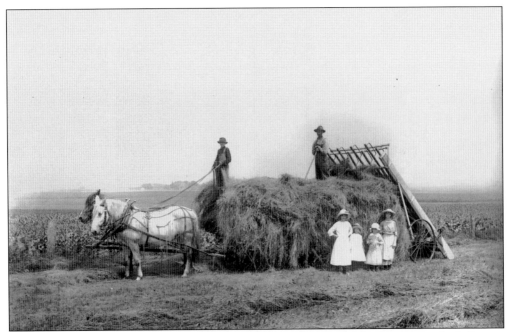

Coming in with a load of hay was a common sight on the farm. The horses wore rawhide fly nets draped from their necks to their tails. Girls wore sunbonnets to shield their faces as they greeted the workers coming in from the field.

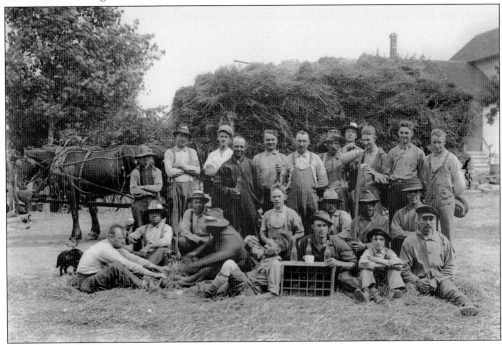

Fellow farmers would come together to help with the threshing. This team of horses has hauled a load of bundled oats to the farmyard to be threshed, which meant separating the grain from the chaff. The workers broke at noon for a big meal prepared by the farm owner's wife in appreciation for the help provided.

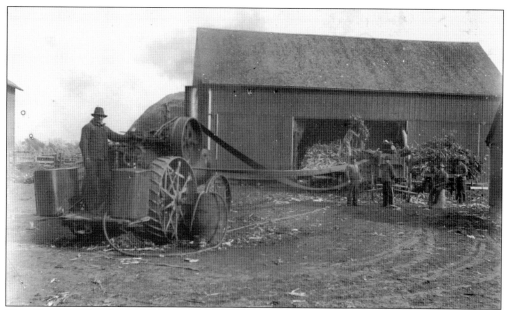

Shredders would pick the ear out of the dry corn. The rest of the stalk would be blown into the barn and used for bedding or fodder. Corn husks were fed to cattle. Nothing went to waste on the farm.

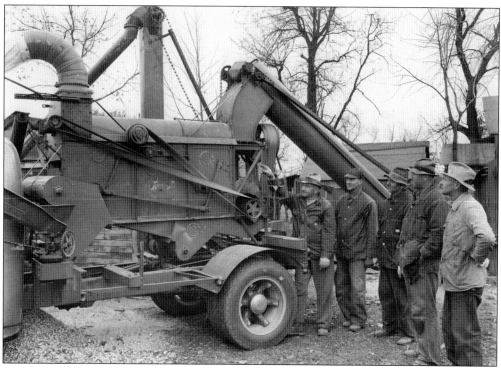

As farming became more mechanized, corn was picked by a machine and stored in a corncrib. In the spring or summer, after the corn had all winter to dry, whoever had a corn sheller would be hired to strip the corn from the cobs. Grain would be loaded on trucks and taken to silos for shipment.

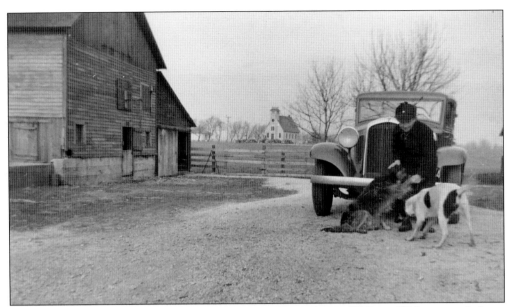

Roy Bartholomae is standing in front of a 1930s Chevrolet on William Wehrmeister's farm. Beyond the fence is the St. John Lutheran Church on Seventy-fifth Street, across Cass Avenue from Lace School.

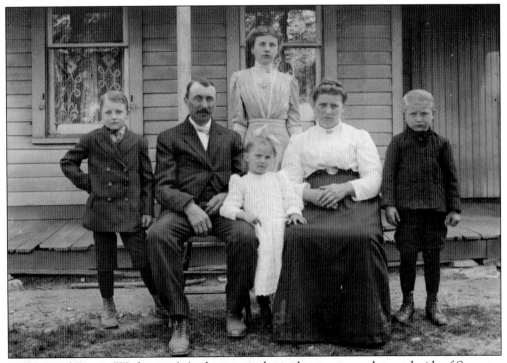

William and Emma (Warkentein) Andermann inherited property on the north side of Seventy-fifth Street west of Cass Avenue upon the death of her parents, Chris and Louisa Warkentein. In front of their farmhouse are, from left to right, Albert, William, Clara, Malinda (behind Clara), Emma, and Herbert. Malinda enjoyed describing growing up in Lace to the students of Eisenhower Junior High School, built on land that was owned by her father.

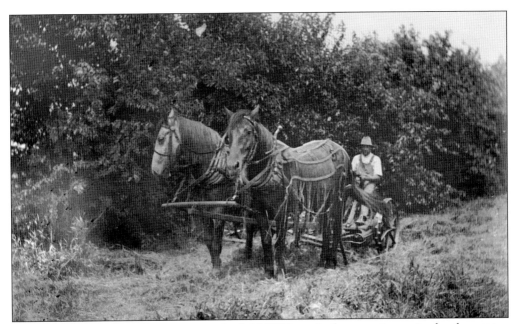

Using the sickle on his right to open up the field, William Andermann is mowing hay by cutting a "back swath." He would go clockwise around the field knocking down the hay. Then he would go counterclockwise around the field and actually cut the hay, creating the back swath.

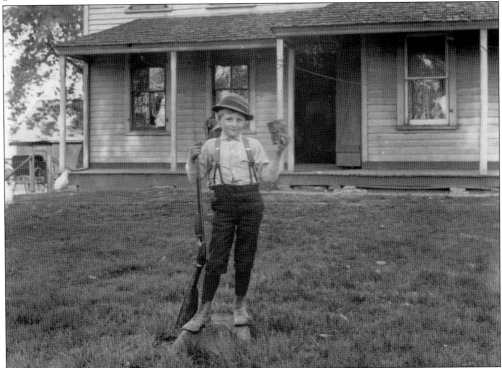

Herbert Andermann proudly poses in front of the farmhouse holding his new shotgun and his first target, a tin can he shot full of holes. A rite of passage for boys his age, Herbert's gun signaled he was ready to go hunting with his father.

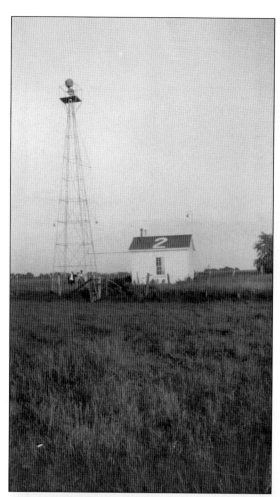

During the 1920s, the federal government organized Contract Air Mail (CAM) flights. Pilots, including Charles Lindbergh, flew Route No. 2 from Checkerboard Field in Maywood to St. Louis, Missouri. The government installed towers, which had kerosene-lamp beacons, like this one on the northwest corner of William Andermann's farm. Herbert's job was to climb nightly and light the beacon to guide the pilots. (Courtesy of Judy Reedy.)

In 1928, one of the CAM planes crashed on William Andermann's farm. Accidents in the early days of aviation were not uncommon as the planes themselves, many left over from World War I, proved dangerous to fly. (Courtesy of Judy Reedy.)

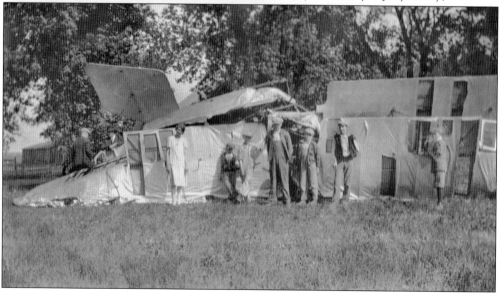

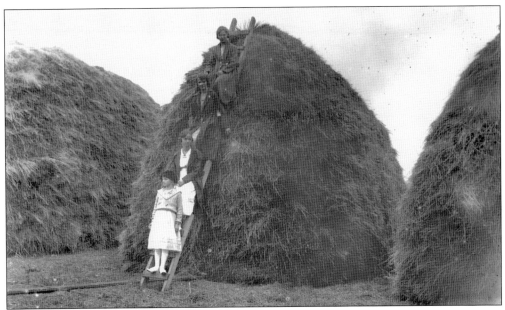

Making a haystack meant standing on the top of the pile of hay and shaping it into a mound with a pitch fork in order to better shed water and keep the hay dry. On a Sunday afternoon after threshing, the Andermann grandchildren are posed on the ladder used to get down from the stack.

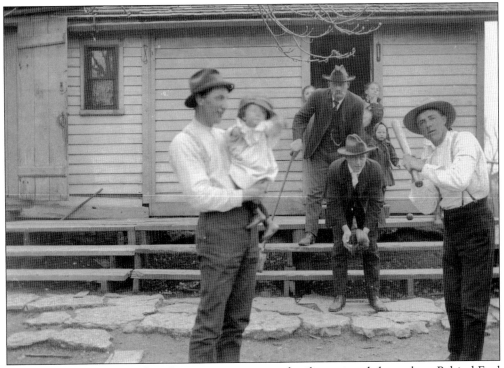

Playing baseball on a Sunday afternoon was one way families enjoyed themselves. Behind Fred Andermann's farmhouse, John Andermann is the catcher, and Edward Andermann is at bat. Grandchildren are peeking out the door that was only opened on Sundays.

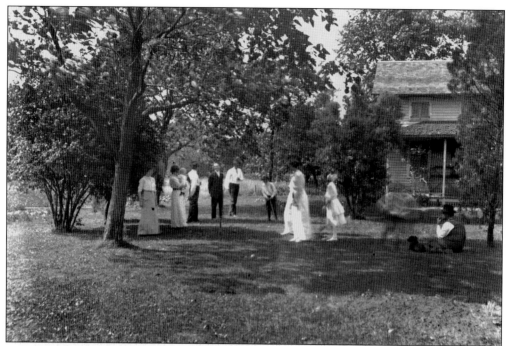
Another favorite pastime was playing croquet on a Sunday afternoon. Croquet was one of few leisure activities in which women could participate.

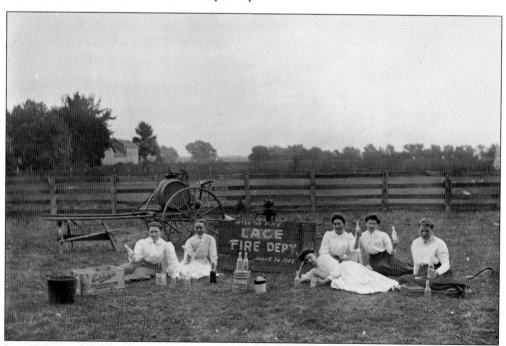
It is August 1, 1909, and it is time to relax, eat, and have some fun "after the fire!" If there had been an actual fire, a rider on horseback would have spread the word for the volunteer fire department bucket brigade to respond with its one-horse wagon holding a barrel filled with water. Chances are the building would have burned to the ground before the firefighters could organize.

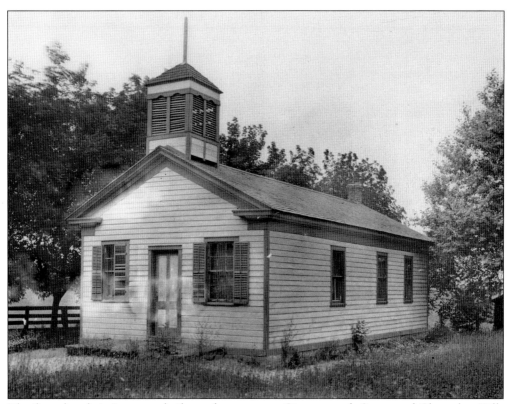

The first church in Lace was built on three acres at Sixty-seventh Street and Clarendon Hills Road, purchased for $30. The 15 charter members of the St. John German Evangelical Lutheran Church signed their first constitution on October 17, 1859.

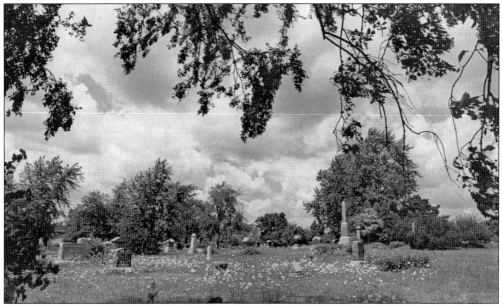

Also in 1859, a graveyard was laid out around the church. A part of the cemetery remains untilled natural prairie with indigenous plants. Eight Civil War veterans are among those buried here.

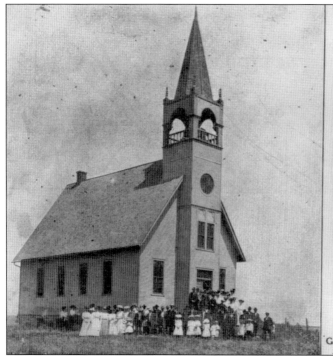

Golden Jubilee of the ev.-luth. St. John's Church at Lace, Illinois, September 26th, 1909.

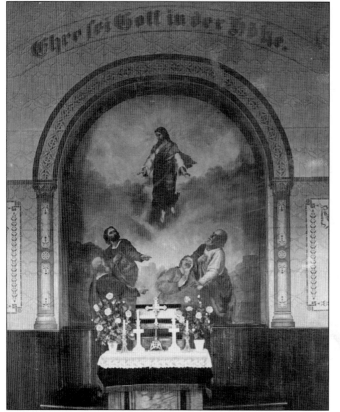

To accommodate a growing population, the church moved in 1899 to the northeast corner of Seventy-fifth Street and Cass Avenue and also changed its name to St. John Lutheran Church. Conrad Buschmann donated an acre of land for the church and purchased the church bell, which is still used today. The church was built in four months, from May to August.

Behind the altar of the church is a picture of the Ascension of Christ, and the inscription over the picture is in German. It translates, "Glory be to God in the highest." A beautiful hand-painted frame enhances the painting. Services were held in German until 1922, when the congregation started using English on the second and fourth Sundays of the month.

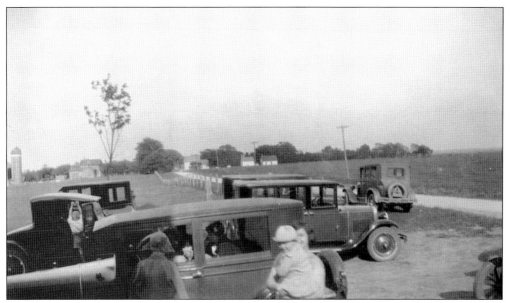

A 1920s view of The Point looking east from Seventy-fifth Street and Cass Avenue shows the home of Dr. Franklin Roe on the left. His great-grandson is Sherrill Milnes, acclaimed operatic baritone. Across Seventy-fifth Street, are, from left to right, the parsonage, church, school barn, and church schoolhouse. To the west of the schoolhouse is the pasture used by the Wehrmeister cows.

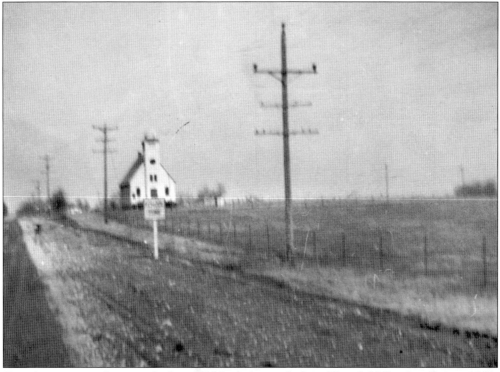

Cass Avenue was photographed in 1936 looking north from Plainfield Road to Seventy-fifth Street. Cass Avenue remained a gravel road until it was extended south to Route 66 and paved prior to World War II.

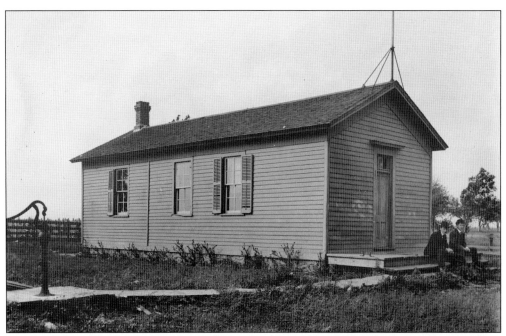

Built in 1859 on the northwest corner of Cass Avenue and Seventy-fifth Street, one-room Lace School was the first public school built in Lace. A land grant from the State of Illinois allowed School District No. 61, as it was identified, to acquire the land for the construction of the school. This school burned in 1924 of unknown causes.

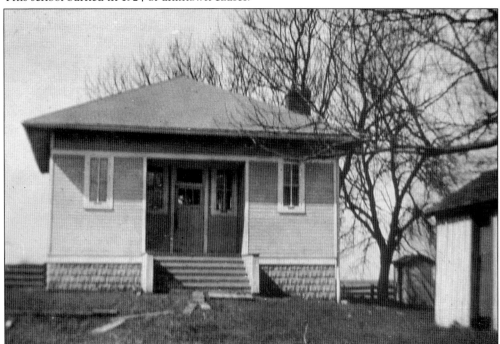

Rebuilt on the same site in 1925, Lace School continued to be used as a classroom until the population growth after Word War II necessitated the building of additional schools. When classes no longer met there, band students practiced in the building.

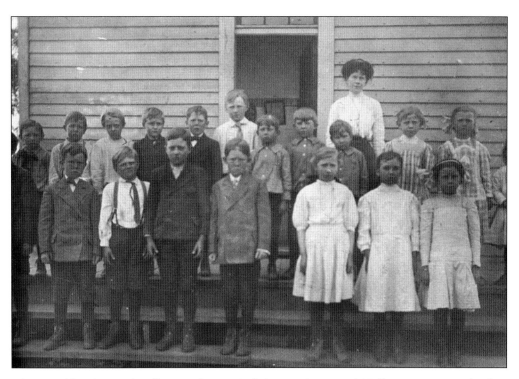

The granddaughters of William and Mary Fell Smart, Grace and Nellie were among the first teachers in the district. Grace Smart poses with her students for a photograph on a special occasion, possibly the first day of school. In another year, inside the school, Nellie Smart used one blackboard for the younger students and the other blackboard for the older students. As was true of the times, the Smart sisters could not be married during their tenure as teachers.

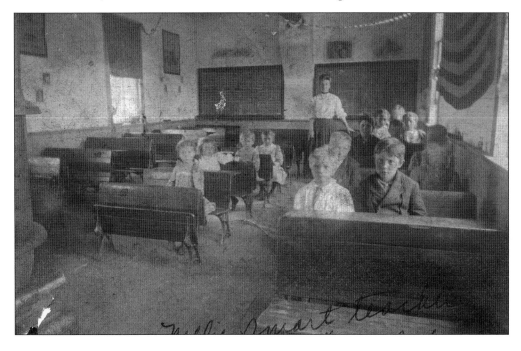

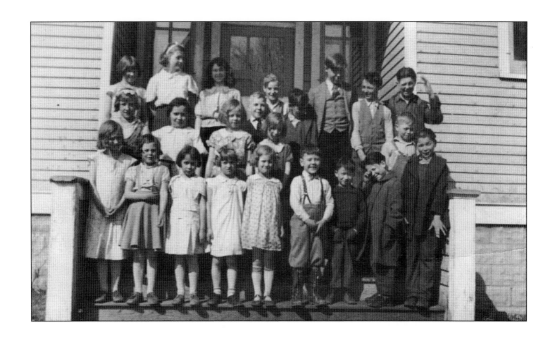

Pictured with her students, Grace Book Stover taught at Lace School from 1933 to 1940. She had to nightly bank the coal furnace for the next morning's heat. Students had to share in the work by dusting, cleaning blackboards and erasers, and toting in water from the well. Stover's salary was $100 a month. During heavy snows, students were brought to school by horse-drawn sleighs.

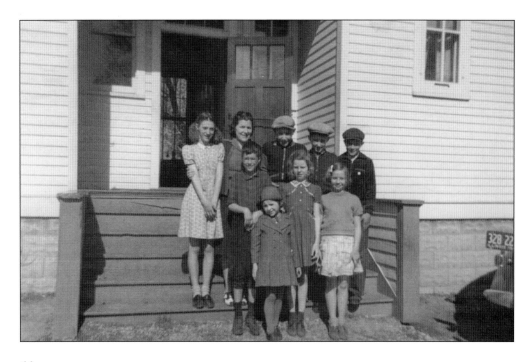

Six

Farm Gives Way to City

Between 1945 and 1969, much happened to change the landscape and nature of Lace. The area that became known as Marion Hills was the first to witness farmland give way to lots for homes. Homeowners, understanding the value of connecting with one another, formed the Marion Hills Civic Organization, chaired by Edward Finch, in 1949. Starting in 1950, the *Village News* newsletter was mimeographed and distributed twice a month to Marion Hills residents. Later, its coverage was expanded to Palisades, Tri-State, Babson Park, Hinsdale, Countryside, Lace, and Tiedtville. It was published until 1953.

Marion Hills women formed the Pioneers Club, forerunner of the Darien Woman's Club. While primarily a social group, its members also raised funds for schools and other groups. In addition to already existing 4-H programs, Boy Scout and Girl Scout troops began. Parents helped to bring about a school band, making uniforms and organizing parades.

The housing boom continued, with Plainfield Highlands and Clarefield homes being built on half-acre lots. Brookhaven I and II subdivisions were started in the mid-1950s, followed by the start of Hinsbrook in 1965. A growing population necessitated the building of new schools and additions being made to existing ones.

The Lace–Marion Hills Youth Club, forerunner of the Darien Youth Club, was organized in 1960 as a baseball club. Involved fathers constructed a baseball field themselves at the corner of Seventy-third Street and Clarendon Hills Road on land that would become the location of Hinsdale South High School. Mothers maintained a concession stand that was built by some of the fathers on a trailer and pulled to every ball game for the sale of refreshments. The money raised was used to support the club.

Gus and Mel's Cities Service was the first gas station in the area. Its slogan was "Don't scream and yell, go to Gus and Mel's." Until the IGA opened at Seventy-fifth Street and Cass Avenue, grocery purchases were made at either of the two mom-and-pop-type stores that were fairly close to Lace. Commercial development continued with the opening of a Dog 'n Suds on Seventy-fifth Street.

While 1956 state highway maps identify the intersection at Seventy-fifth Street and Cass Avenue as Lace, in actuality only Lace School and St. John Lutheran Church remained as vestiges of Lace.

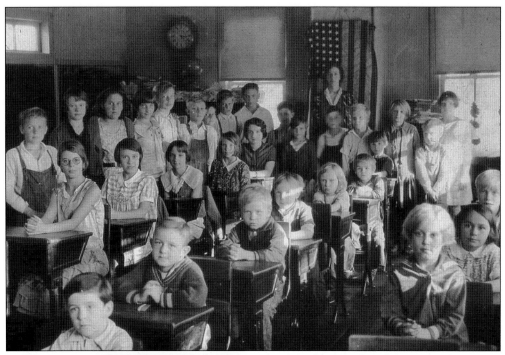

A brick building replaced the original Cass School that burned in the early 1900s and remained a one-room schoolhouse well into the 1930s. The interior exemplifies the standard midwestern classroom setting. Eventually, a section of land on the northwest corner of Bailey and Frontage Roads was donated by the Elisha Smart family for a new school to accommodate increasing enrollment. A brick school with an office and eight classrooms was built there in 1953.

Pastor Abe Vanderpoly stands outside the back door of the Cass Episcopal Methodist Church in 1940. Patricia Smart, a descendant of William Smart, married Ken Maack in this church in 1951. The church was also a polling place for Lace and Cass. After Interstate 55 was built, the 1834 church ceased to exist. (Courtesy of Patricia Smart Maack Ormsbee.)

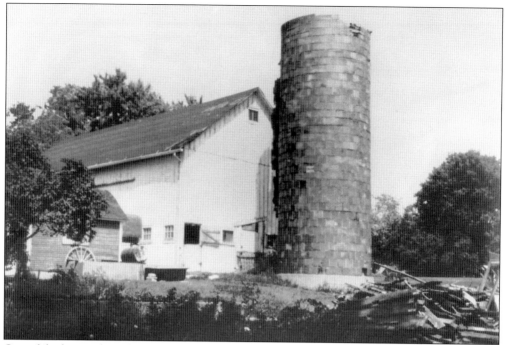

One of the last working farms in DuPage County, Fred "Fritz" Prueter's farm stood on the east side of Cass Avenue at present-day Seventy-first Street. The silo fell during a storm, and the remaining round concrete foundation was used as a pigpen.

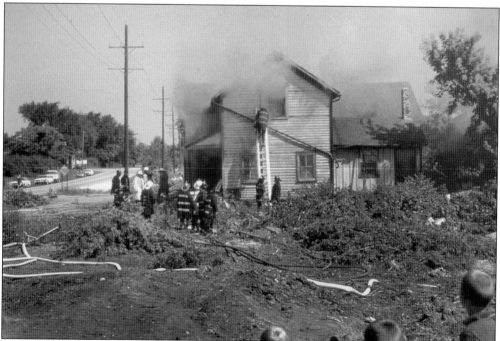

Fred's farmhouse was burned intentionally, allowing the volunteer firemen to practice their firefighting skills and make way for the building of the Hinsbrook subdivision. Farm buildings began to disappear as the landscape changed from rural to urban.

The farmhouse of Homer, a son of Elbridge Andrus, stood on property that is today along the South Frontage Road of Interstate 55. Homer's son Robert also farmed the property that included a blacksmith shop, the only one remaining in the area. Homer was a farrier, shoeing horses, and also repaired farm machinery and wagon wheels for local farmers.

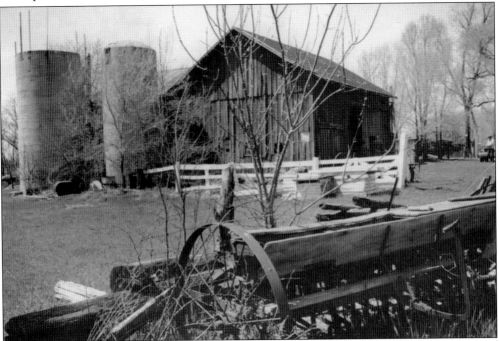

The barn on Homer's farm was joined with wooden pegs; no nails were used. The 17-acre property included a milk storage shed and a tornado shelter cut into the earth. The blacksmith shop, identified with a Smithy sign, was established in 1900.

The 320-acre Emil Eichhorst farm was sold to a group of Chicago men to establish today's Clarendon Hills Cemetery on the west side of Cass Avenue at Sixty-ninth Street. Emil and Frances's house still stands on the grounds.

Allen and Polly Campbell purchased land in 1952 that was previously part of the Eichhorst farm and named their property Lucky Lane Farm. Allen was president of the Lace–Marion Hills School Board and was a familiar sight mowing the school lawn. Residents remember the family's annual August corn roast and the many pool parties. In 1964, they hosted a traditional Thanksgiving dinner for international scientists working at Argonne National Laboratory, now a US Department of Energy facility for scientific and engineering research. (Courtesy of Barbara Campbell Smith.)

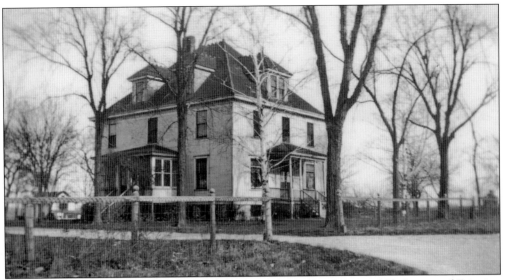

Well-known to local residents, Jacob Klein's farm was located at Seventy-fifth Street and Fairview Avenue. Along with cattle, Jacob was a dealer in wild horses that were purchased in the West, shipped by train to the Fairview Avenue station, broken by local farmhands, and then sold as delivery horses to be used mainly by the Bowman Dairy in Chicago. He is interred in a mausoleum in the St. John Lutheran Church Graveyard on Clarendon Hills Road.

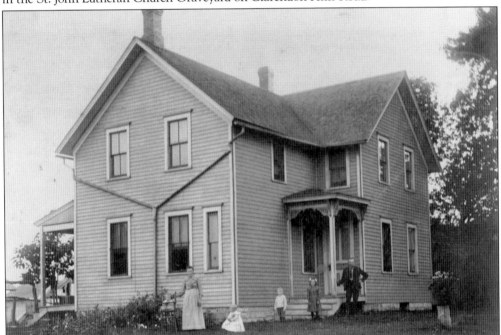

The farmhouse of August and Mary Mandel's 80-acre dairy farm was located between High Road and Clarendon Hills Road on the south side of Plainfield Road. The Mandels arrived in Lace around the turn of the 20th century. Carl, one of their sons, was a well-known boxer in Chicago using the name "Tuni." Pictured, from left to right, are Harold (in high chair), Mary, Ada, Elmer, Adele, and August. Still occupied today, the house became part of the Marion Hills area when the land was sold in the 1940s. (Courtesy of Elvira Ruff.)

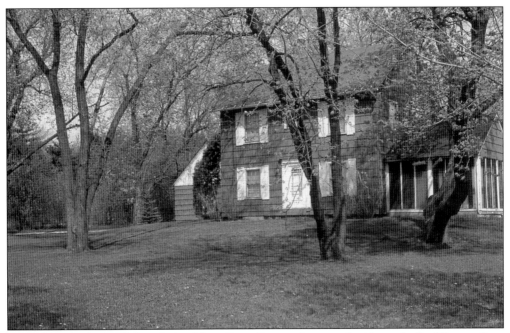

In 1943, the Trcka family bought land from Ernst Prueter that stretched from the Fred Prueter farm to Sixty-seventh Street along the east side of Cass Avenue. Foregoing farming, they established a Christmas tree farm that is fondly remembered by families who cut their own Christmas trees. The remaining evergreens are among the Woodlands of Darien town homes. The house and the barn are pictured as they looked in the 1950s.

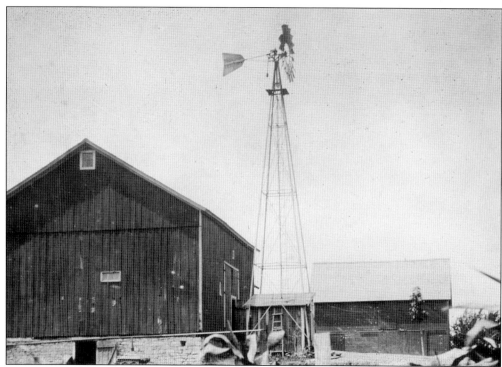

Charles Schmidt grew up on a farm on Clarendon Hills Road that stretched from Sixty-ninth Street to Plainfield Road that was owned by his parents, another early family in the area. Present-day Seventy-first Street follows the original driveway into the farm. The Darien Community Park covers 22 acres of land that Charlie sold to the City of Darien to be used specifically as a park.

The first homeowners in the area after World War II marveled at the sight of virgin prairie, as in this view overlooking Charlie Schmidt's farm in 1964, still ablaze with natural vegetation on which cows grazed. (Courtesy of Debra Kieras.)

Retiring when his farm was sold, Charlie Schmidt served as a crossing guard at the corner of High Road and Plainfield Road for Marion Hills School. Seen by many as a grandfather figure, he always had a smile on his face, and parents trusted him to watch out for the safety of their children.

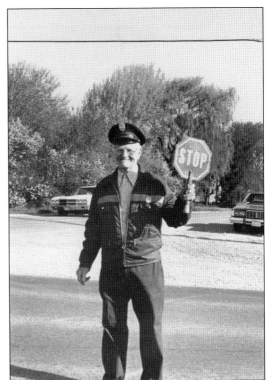

Not willing to sit idly by, Charlie welcomed the opportunity to share his memories with schoolchildren who delighted in hearing what it was like to attend one-room Lace School. He also told them how families lived off the land, planting corn and oats with horse-drawn plows and harvesting huge gardens each summer.

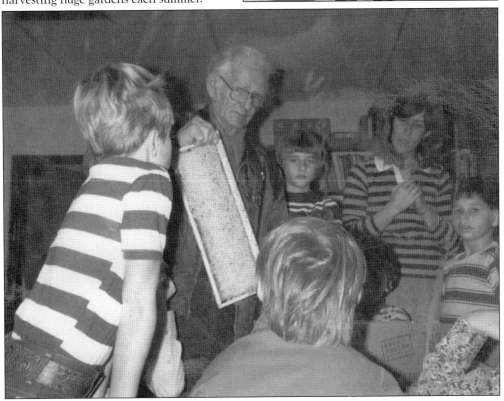

Elizabeth Ide was a beloved teacher and principal at Center Cass School from 1942 to 1954 where she established the first school library. When the well for the school became contaminated, she brought eight gallons of drinking water from home each day. Passionate about teaching, Ide returned to the profession after her retirement from Center Cass and taught at Lace School for a short time.

The community recognized Elizabeth Ide's service to children and, in 1969, named a kindergarten-through-third-grade school in her honor. The school is on Manning Road and is part of School District No. 66.

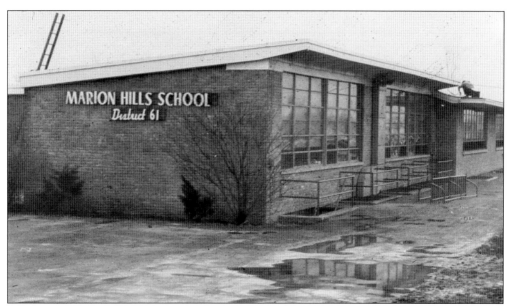

In 1949, a referendum passed to purchase land at Eleanor Street and Plainfield Road for the construction of Marion Hills School, which opened in 1951. It had four classrooms and a gym in the basement. Its name referenced the familiar Marian Hills Seminary.

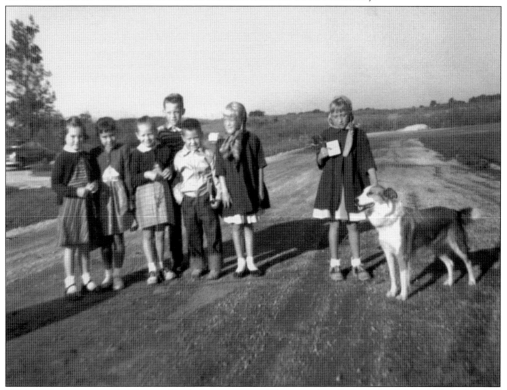

Without bus service, children walked along unpaved Seventy-fourth Street to Marion Hills School, a lengthy hike. However, they had Duchess the dog to accompany them. In the background is the prairie where Hinsdale South High School was built. (Courtesy of Debra Kieras.)

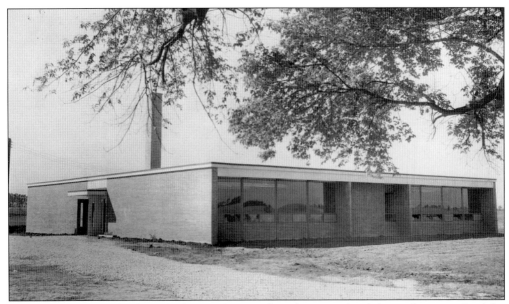

A new elementary school was built in 1957. Together, the new school, located just north of the first Lace School, and the existing Marion Hills School were known as Lace–Marion Hills School. The new building housed grades five through eight. Students in first through fourth grades attended what was formerly known as Marion Hills School. When the new building opened, for the first time in the district's history, there was one teacher for each grade level. (Courtesy of School District No. 61.)

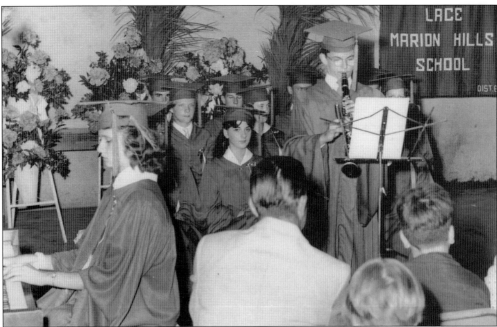

Barbara Campbell Smith, the daughter of Allen and Polly Campbell who lived at Lucky Lane Farm, provides piano accompaniment for another student playing the clarinet during her eighth-grade graduation from Lace–Marion Hills School in June 1958. Smith was also the valedictorian of her class of 10 students. (Courtesy of Barbara Campbell Smith.)

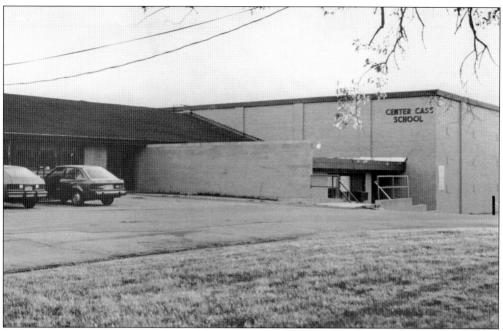

The second Center Cass School was closed when the third Center Cass School opened in 1951 to accommodate the growing needs of District No. 66. In keeping with a tradition, the second school's cowbell that was used to call children to school was brought to the new school at Eighty-third Street and Lemont Road.

The second high school in School District No. 86, Hinsdale South High School opened in September 1965 on the east side of Clarendon Hills Road at Seventy-fifth Street. Prior to its opening, area students attended Hinsdale Central High School. Freshmen, and sophomores who had attended Hinsdale Central for their freshman year, were the first students to attend what was then considered a state-of-the-art school. Artist Carl Heldt designed a wire relief mural, titled *Famous Faces*, for the school foyer.

While much of the farmland in the area was disappearing, open stretches of land where crops grew could still be seen. This field of corn on Plainfield Road will eventually be home to the Darien Sportsplex. (Courtesy of Judy Hnilo.)

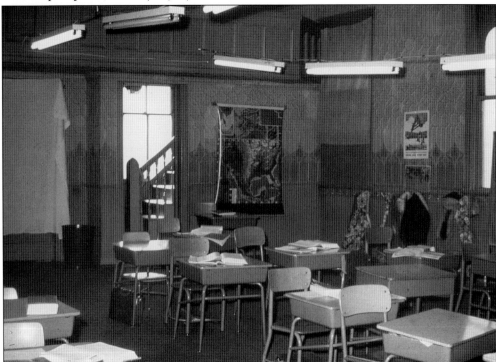

Prior to the building of Eisenhower Junior High School, as the grade school population boomed, then superintendent Mark DeLay of District No. 61 scrambled for classroom space. Alternative sites, such as a basement area of the second St. John Lutheran Church, were devised.

School District No. 61, again responding to overcrowded conditions, opened Eisenhower Junior High School in 1969 on land that was William Andermann's farm on Seventy-fifth Street, where the CAM tower and beacon once stood.

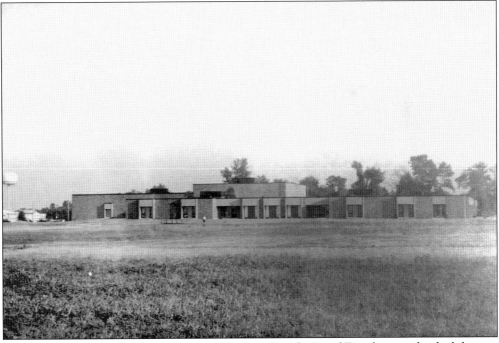

Eisenhower Junior High School was named for Pres. Dwight David Eisenhower, who died the year it opened. As the school's foundation was being dug, students found animals bones and Indian artifacts during an archaeological exploration of the ground.

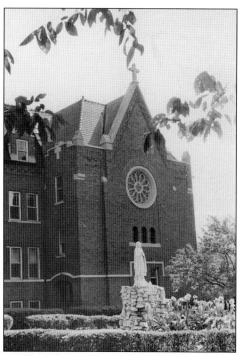

Marian Fathers Seminary was established as an educational institute in 1922 and was located north of Sixty-third Street on Clarendon Hills Road. Marian Hills Seminary, as it became known, was the first house of worship for Saint Mary's parish. A beautiful tree-lined drive led to the seminary, situated on a knoll. (Courtesy of John Poteraske.)

The 220-acre seminary farm extended to Route 83 on both sides of Sixty-third Street. Self-sustaining, it supported 40 head of cattle and a flock of chickens. The brothers farmed, and the nuns did the housekeeping and meal preparation. (Courtesy of Judy Hnilo.)

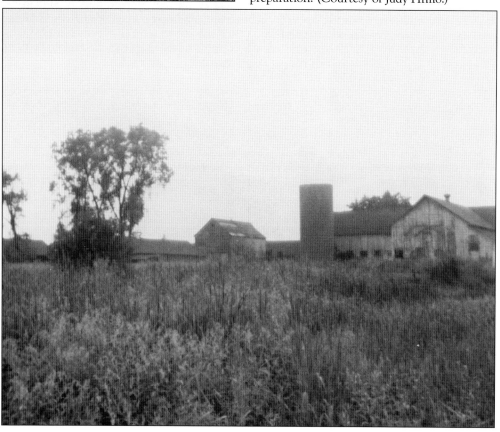

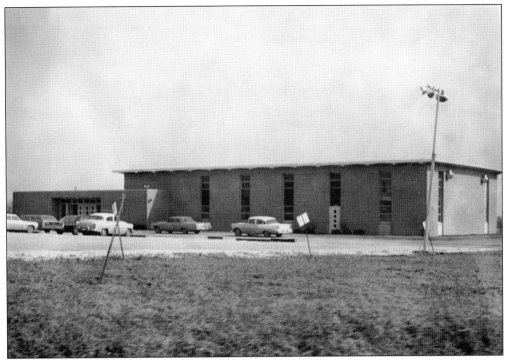

St. Mary's Mission became a parish in 1959. Eight acres of land were purchased at Plainfield Road and Seventy-fifth Street for a church and school, and the school officially opened in 1963 with solely first-grade students. In 1964, the Sisters of St. Casmir agreed to teach at St. Mary's. By 1966, the school included students in first through eighth grades.

Services at St. Mary's were first held in the school gym. The gym was a multipurpose room, and curtains closed off the altar when needed. The seats were folding chairs, with kneelers attached. In 1982, the parish name changed to Our Lady of Peace. (Courtesy of Rose Courtney.)

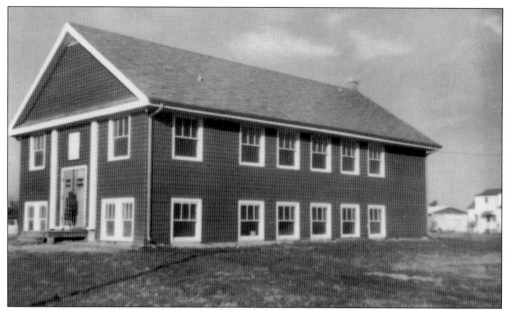

Marion Hills Bible Church parishioners held their first organized Sunday school class in 1952 in the basement of Marion Hills School. In 1956, they built a church across the street at Plainfield and High Roads. The steeple was added to the church in the early 1960s.

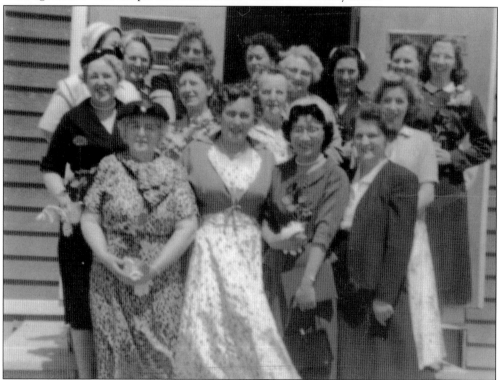

Women members of the Marion Hills Bible Church gather for a photograph outside the building. The closeness of the congregation was evident in the fellowship they enjoyed with each other. The women often baked cookies for the children at Marion Hills School.

With the loss of businesses at "The Point," commercial activity changed to the intersection of Seventy-fifth Street and Cass Avenue. However, with only two gas stations, as seen from an unpaved Plainfield Road in the 1960s, residents had to go to elsewhere to shop for groceries and other items.

One stop sign was all that was needed to manage traffic at the intersection of Seventy-fifth Street and Fairview Avenue. In this view looking north onto Fairview Avenue from Seventy-fifth Street, with the Klein farm gone, the area awaits future development.

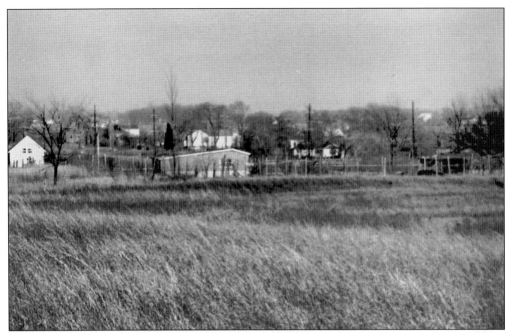

Shown in the early 1950s, the Marion Hills area was the first to see farmland give way to individual homes not part of an organized development. Originally to press for services from DuPage County, homeowners joined together to form the Marion Hills Civic Association in 1949. (Courtesy of Samuel Kelley.)

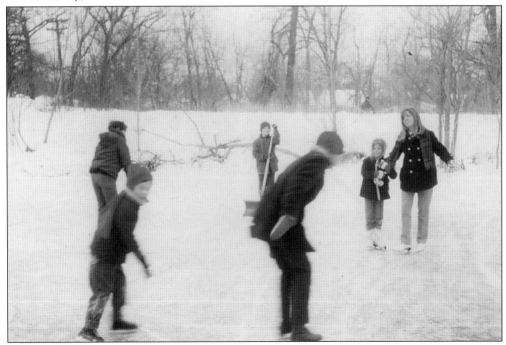

In 1946, the Isbrand Harder family was the first of the new families to move into the Marion Hills area. Their home still stands on Crest Road. Children enjoyed skating on what was known as Harder's pond, across the street from the house. (Courtesy of Samuel of Kelley.)

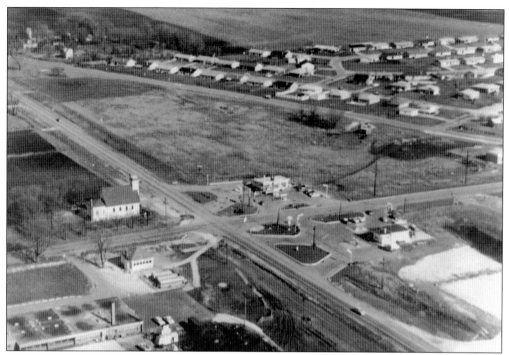

Brookhaven I subdivision had been built, but not Brookhaven II, when this aerial view of The Point was taken. In the upper left corner is the Fred Andermann farmhouse. The field in the bottom right belonged to the Rohmer family and is the location of the photograph on the book's cover.

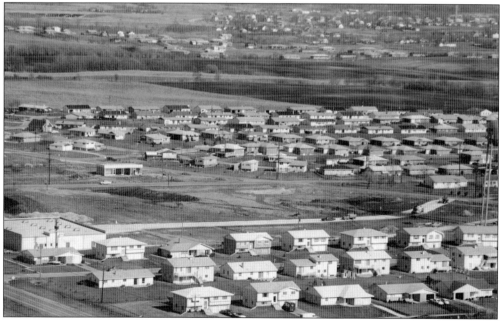

Taken a few years after the above photograph, this aerial view shows both Brookhaven subdivisions. The road in the forefront was the access road off of Plainfield Road into the IGA, the first grocery store in the area. Notice the number of homes in the upper part of the photograph on the land that was previously empty.

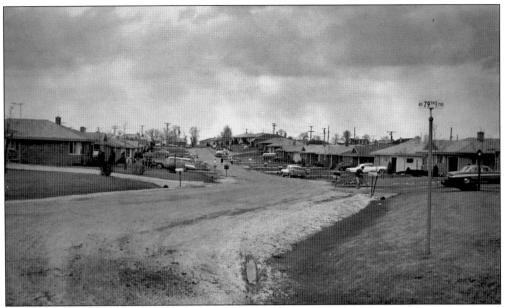

The ditches in front of the homes in Brookhaven I were for drainage until storm sewers were installed. Without public transportation, cars were now a necessity, as evidenced by the variety of vehicles parked in the driveways.

The developer of both Brookhavens, including the shopping center, constructed a public water supply and a sewage collection and treatment system to serve the new community, unofficially known as Brookhaven. They were eventually purchased by DuPage County.

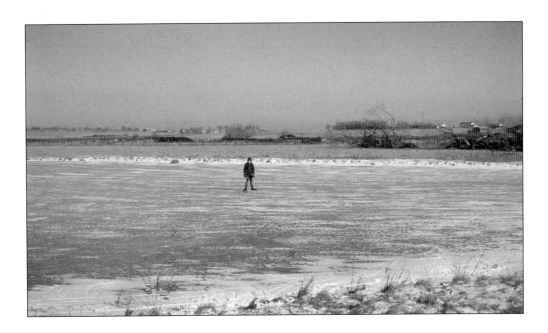

Ice-skating was a favorite pastime for children. Above, in 1965, Ken Wernli is skating on the slough pond that Conrad Buschmann built in his long-gone pasture. Below, one year later, the homes of the Hinsbrook subdivision, nonexistent in the first photograph, are behind the skaters. From left to right are George Griggs, Karen Kilroy, Debbie Griggs, Keith Wernli, Tim Metza (behind Keith Wernli), Ken Wernli, Laurie Griggs, Mary Brier, Cindy Watts, ? Brand, and Joyce Curcio.

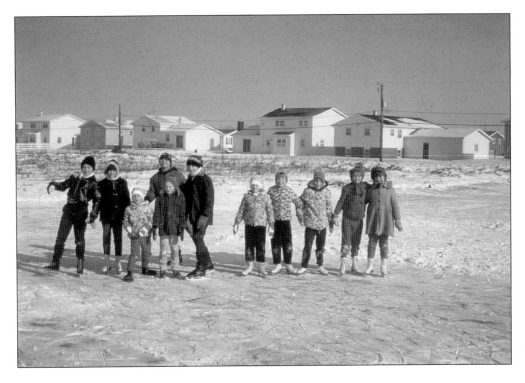

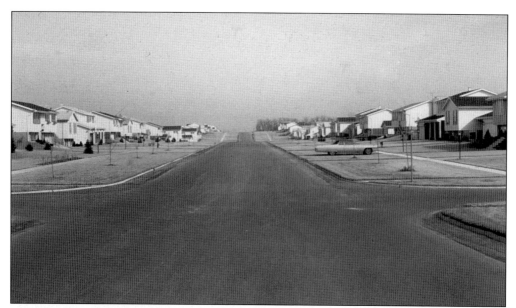

Developers purchased farmland and subdivided the land into quarter-acre lots. The homes in the Hinsbrook subdivision were started in 1965 on what had been the Prueter farm and the Schmidt farm. The newly planted saplings at the intersection of Richmond Avenue and Seventy-first Street are barely beginning to grow. The subdivision included a clubhouse and pool.

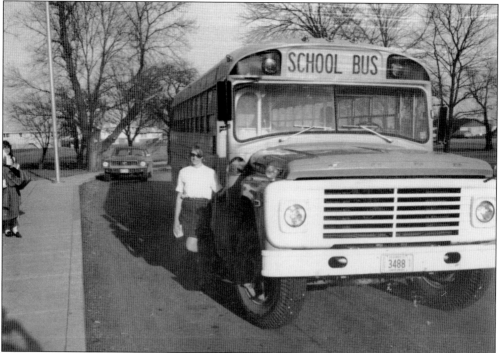

District No. 61 began bus service when the second Lace School opened. The bus traveled back and forth between the two buildings collectively known as the Lace-Marion Hills School. Miriam Hawken, mother of 10, was hired as the first bus driver because, as she was fond of saying, most of the kids on the bus were hers. (Courtesy of Nancy Hawken Curtis.)

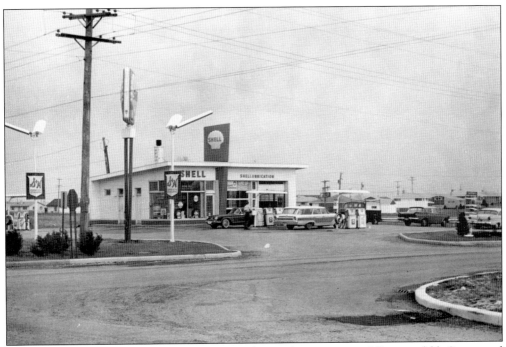

The Shell station owned by Al Fatla was on the southeast corner of Seventy-fifth Street and Cass Avenue. The Enco station was on the southwest corner of Seventy-fifth Street and Cass Avenue. Significant in light of the need for cars, gas stations were a logical choice for early businesses. However, the horse standing in front of the service bay below harkens back to a time now disappearing.

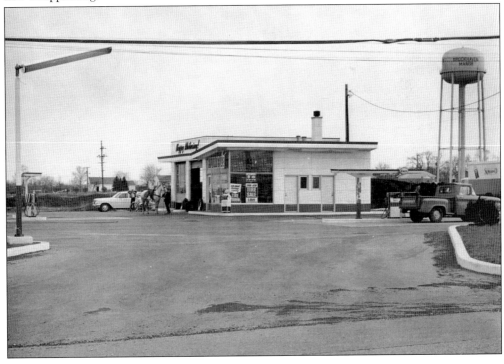

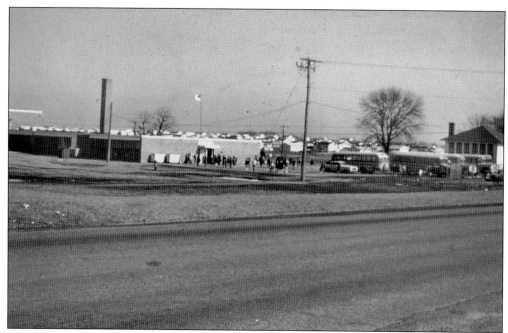

The back of Lace School is seen in this view from the two-lane Seventy-fifth Street looking northeast. While Hinsbrook has grown, there is as yet no commercial development on the northeast corner of Seventy-fifth Street and Cass Avenue. More school buses meant a growing number of school-age children.

Growing boys are playing baseball in the field behind Lace School. In 1959, LaMar Rodgers, Elmer Kalny, Gene Kolling, Lee Lipman, Bob Kline, and Ed Lindberg were instrumental in forming a youth baseball league known as the Lace–Marion Hills Youth Club. Girls were cheerleaders and wore uniforms made by mothers. Team nametag pins consisted of alphabet noodles glued onto colored toothpicks. In 1972, the league became the Darien Youth Club.

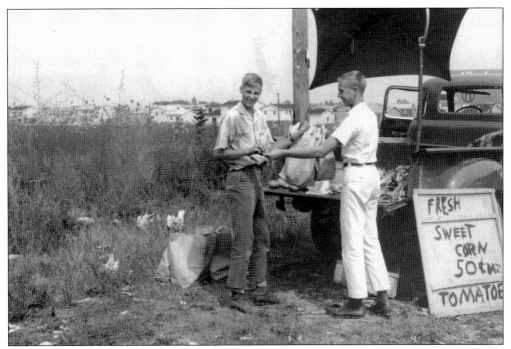

In August 1967, John (left) and Tim Hawken are selling corn that was grown at the seminary. Their stand was at Clarendon Hills and Roger Roads. The land that became Darien Community Park is behind them. (Courtesy of Nancy Hawken Curtis.)

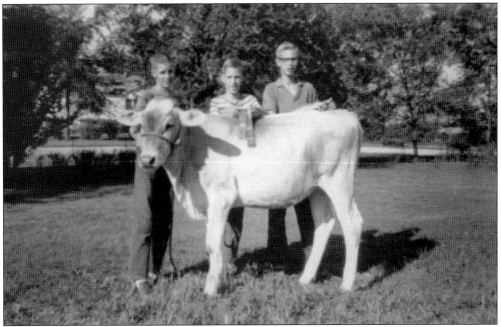

Pictured from left to right are Mark, Tim, and John Hawken with their 4-H DuPage County prizewinning cow. As the area urbanized, many area children continued to participate in 4-H clubs, long associated with rural residents. 4-Hers raised livestock, grew vegetables, exhibited baked goods, and sewed projects. (Courtesy of Nancy Hawken Curtis.)

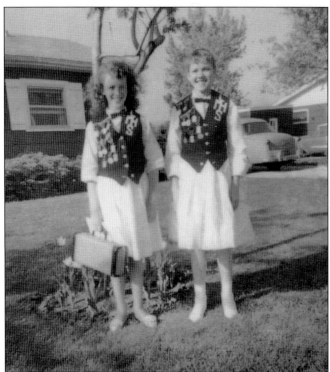

Sandra Piotrowski (left) and Karen Knecht are wearing the first band uniforms of Lace–Marion Hills School. The girls wear white pleated skirts, white blouses, and red bow ties. Pat Renken designed the red felt vests that parents helped make. The boys also wore the vests, with black slacks, white shirts, and red bow ties. (Courtesy of Sandra Chereshkoff.)

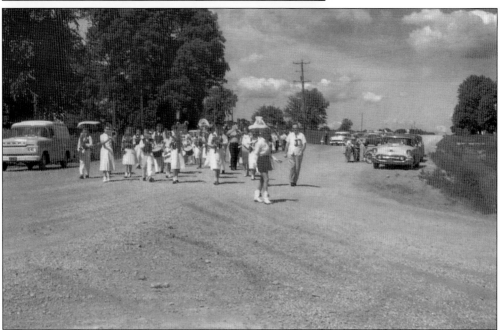

In the early 1960s, organized by Gower School's band director Roland Pitts, the members of the Lace–Marion Hills School Band are the only participants in the first summer parade. Marching between the two district schools, they are arriving at The Point where Seventy-fifth Street on the right meets Plainfield Road on the left. The Point, once the hub of community life in Lace, was now vacant land between two gravel roads. (Courtesy of Sam Kelley.)

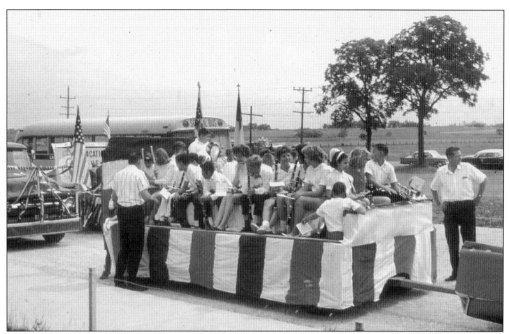

Because it began at 8:00 a.m., the first parade drew a small audience. Band parent John Klancir, facing the students on the float, worked with Roland Pitts and decided to plan the next parade for the Fourth of July and to start it at 9:00 a.m. They included more participants and added floats, like this 1962 band float.

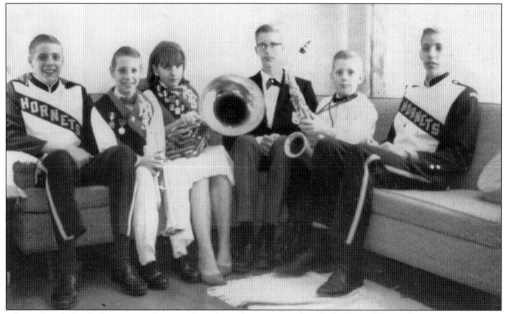

The schools had their own distinct band uniforms. On the far left and far right, Mark and Tim Hawken are wearing the band uniform of Hinsdale South High School. Next to Mark, Tom and Susan Hawken are wearing the Lace–Marion Hills School Band uniform, and John Hawken in the middle is wearing the band uniform of Hinsdale Central High School. Walt Hawken is sitting between John and Tim. (Courtesy of Nancy Hawken Curtis.)

In the 1950s, the Pioneer Club was formed as a service group of women dedicated to raising funds for area groups. The Darien Historical Society has this copy of the *Pioneer Recipes* book containing recipes contributed by the members and sold to raise funds.

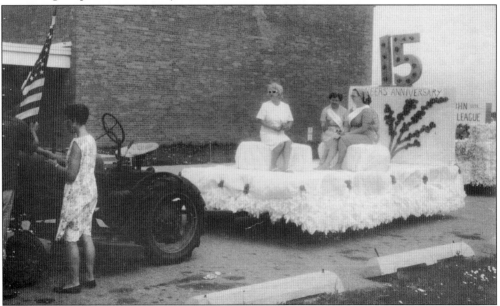

The Pioneers celebrated their 15th anniversary with a float in the Fourth of July parade. The Pioneer Club was the first women's club in the area. In 1970, another women's club, the Darien Woman's Club, was formed.

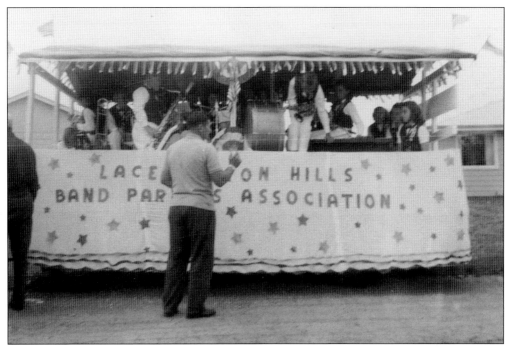

From its humble start, band participation in the Fourth of July parade grew to include this float representing the Lace–Marion Hills Band Parents Association. District No. 61 parents have continued to actively support the musical efforts of their children.

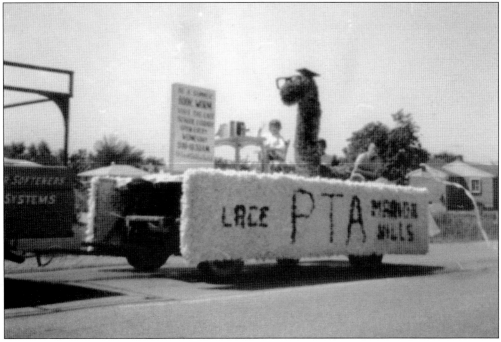

As the population of the schools grew, parents formed parent-teacher associations (PTAs) to work hand in hand with the schools to promote quality educational programs. Pride in the school system is evident in this float for the Fourth of July parade in 1964.

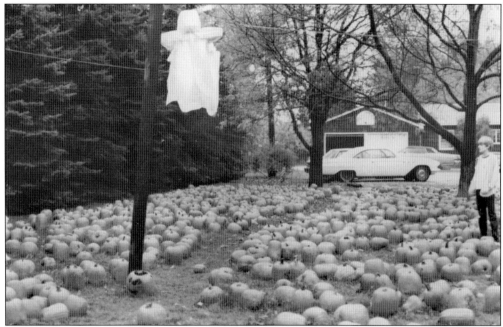

Starting in 1967, come October of every year, the front yard of Jim and Ann Dedic's home on the west side of Cass Avenue south of Seventy-fifth Street was filled with pumpkins grown in the field behind their home. Children delighted in going up and down the rows of Dedic's Pumpkin Patch trying to decide which one to choose. (Courtesy of Joel Dedic.)

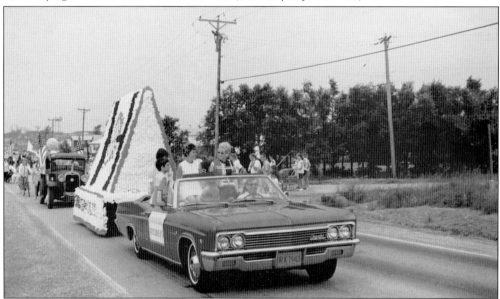

Members of the Hinsbrook Newcomers Club created a float for the Fourth of July parade. While riding together in one car during the parade, G. Del Hayenga, Samuel Kelley, and Charles Schwartz, presidents of three of the five homeowners associations, began discussing issues of concern to their members. All five met on September 8, 1968, at Hayenga's house to continue the discussion. The gathering germinated the process leading to the incorporation of Darien. (Courtesy of Ingrid Gross.)

Seven
DARIEN TAKES SHAPE

Prior to 1958, homeowners in the Marion Hills area tried twice to incorporate as a village. Both attempts failed by a close vote. By the mid-1960s, Brookhaven, Hinsbrook, Clarefield, Knottingham, and Marion Hills all had homeowners associations. In 1964, the Marion Hills homeowners made another attempt at incorporation, which was blocked by the Village of Willowbrook. A later attempt to annex to Willowbrook also failed. Brookhaven considered annexation to Westmont in 1965, but that did not succeed.

Identifying common concerns including police protection, zoning regulations, street maintenance, and flooding, the Combined Homeowners Study Group was formed in 1968 to consider the options of incorporating, annexing to another village, or remaining unincorporated. The study group recommended incorporation, thinking it could be accomplished economically and provide the following: police protection, building and zoning regulation, and the ability to acquire state motor fuel tax funds, collect sales taxes, and license and regulate businesses and commercial activity. The results of a straw poll taken following the presentation of the group's report to the members of each homeowners association favored incorporation. Knottingham ended its participation in the committee after the opinion poll. As they moved forward, Plainfield Highlands was included with Clarefield. Following the opinion poll, the Combined Homeowners Study Group changed its name to the Combined Homeowners Committee for Incorporation.

Legal advice recommended incorporating as a city rather than a village. Doing so required a population of 7,500 and an area not to exceed four square miles, and meant that the area did not need the approval of communities within one square mile of the proposed city. Once the DuPage County Circuit Court accepted a school survey conducted by Lillian Brown as valid evidence of the population numbers and approved the petition signed by the voters in the subdivisions requesting a vote on the matter, the stage was set for the vote on incorporation.

After incorporation passed and the first mayor and city council were elected, the hard work of organizing the city to function began. F. Willis Caruso was appointed city attorney, and committees were established. Darien was on its way to becoming "a nice place to live."

Efforts were made prior to incorporation to address the lack of services. Hoping to replace septic systems with a sewer system, the Marion-Brook Sanitary District was formed in August 1963. From left to right are the members of the first district board—Elmer Kalny, George Toda, and Gene Kolling. This was the first attempt at organization to bring improvements to the community.

Wording on the sample ballot explains the referendum that was put to the voters. The referendum to approve sewer bonds to form the Marion-Brook Sanitary District was passed with overwhelming support.

This map of the area subdivisions sets the stage for the route that led to incorporation. Each subdivision had a homeowners association, led by the following people: Brookhaven president Charles Schwartz, Clarefield president Robert Maxwell, Hinsbrook president G. Del Hayenga, Marion Hills president Samuel Kelley, and Knottingham (not shown) president Ray Klouda.

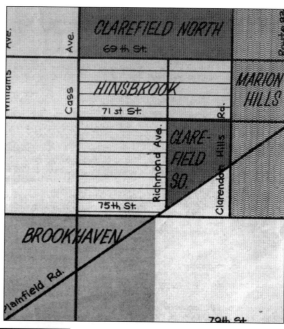

After the Fourth of July parade, members of the subdivisions formed the Combined Homeowners Study Group. G. Del Hayenga (pictured) served as president and was also designated as the person to communicate with the press. At this point, Robert Kampwirth replaced Charles Schwartz as the representative of the Brookhaven Homeowners Association. Recognized in 1972 as Darien's first Citizen of the Year, Hayenga's leadership skills kept the committee united and meetings focused.

A unique city name had to be chosen for the referendum ballot on incorporation. Inspired by a visit to Darien, Connecticut, Samuel Kelley, member of the Combined Homeowners Committee for Incorporation, suggested the name *Darien* for the proposed city. Other proposed names were *Lace*, *Clarebrook Hills*, and *Lacebrook*. Highly regarded for all his civic-minded endeavors, Sam has played a stellar role in the community.

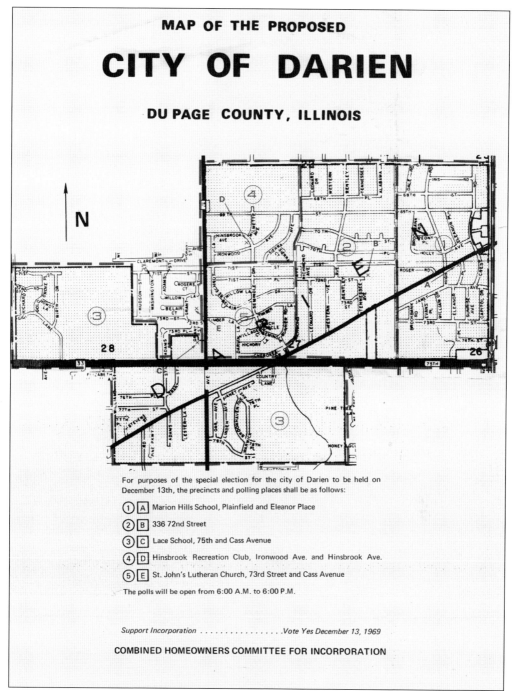

A map of the proposed city of Darien, distributed by those in favor of incorporation, shows the designated polling places for the vote on incorporation that was held on December 13, 1969. The boundaries of the proposed city were Sixty-seventh Street on the north, Seventy-ninth Street on the south, Route 83 on the east, and Fairview Avenue on the west. Polling places included the schools, Hinsbrook Recreation Club, St. John Lutheran Church, and the home of a resident on Seventy-second Street.

Don't Be Fooled!

Vote "NO" on Incorporation
SAT., DEC. 13TH

HERE'S WHY IT'S CRITICALLY IMPORTANT FOR YOU TO GET OUT AND VOTE "NO".

* Incorporation would cost you from $180 to $240 in extra taxes each year. And that's just for minimal services. No parks! No frills! No extras!

* Our community has been cunningly deceived by a fictionalized budget estimate and absurd promises that you'll only pay around $15 in extra taxes the first year.

* Some people have been fooled and will vote "yes". Others who don't want incorporation might not bother to vote because they think $15 isn't worth the effort.

THE REFERENDUM WILL BE CLOSE.

YOUR ONE "NO" VOTE IS CRITICAL!

REMEMBER, A WRONG VOTE NOW CAN NEVER BE REVERSED LATER!

Vote at your regular political polling place -- if in doubt about its location call the Downers Grove Township office -- 968-0451. Polls open 6 AM to 6 PM. For a courtesy ride to polls call 964-4261 or 971-1541.

Citizens for the Facts on Incorporation.

Those who opposed incorporation organized to urge a vote against it using the symbol of a fishhook and arguing "Don't Get Hooked!" "Don't Bite!" "Don't Get Caught!" Their greatest concern was that taxes would increase. Those who urged a yes vote countered with "Get Hooked!" with good government, a minimum city tax, and better services.

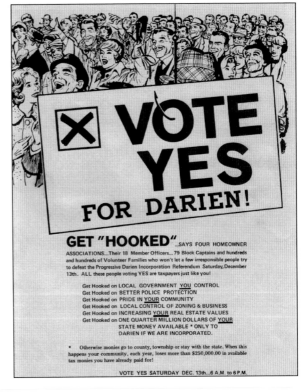

The smile on Alfred Stramaglia's face as he hears the results of the incorporation vote told the committee members gathered in his home the news they were hoping to receive. Afterwards, he and several others drove through their new city blasting horns and cheering. Al is thought to be the person who coined the motto that Darien is "a nice place to live."

"Welcome to Darien, Illinois, the newest and brightest city"—a hastily made sign, held by Ira Bresof, expresses the sentiments of those who had worked tirelessly to bring this goal to fruition. The election night vote total was 1,206 in favor of incorporation and 1,169 against it. The measure passed by a slim margin of less than 50 votes.

SPECIMEN

The following is a facsimile of the Official Ballot to be voted at a General Municipal Election, City of Darien, and State of Illinois, to be held on Saturday, February 21, 1970.

Robert M. Haenisch
Clerk of the Circuit Court
of DuPage County, Illinois

OFFICIAL BALLOT

NOMINEES FOR MAYOR, CITY CLERK, CITY TREASURER AND ALDERMEN OF THE CITY OF DARIEN, ILLINOIS, AT THE GENERAL MUNICIPAL ELECTION.

(Instructions to voters: Place a cross (X) in the square to the left of the candidate for whom you desire to vote.)

FOR MAYOR
(Vote for One)
- ☐ EDWARD W. JENKINS
- ☐ BASIL L. KIMBALL
- ☐ _____

FOR CITY CLERK
(Vote for One)
- ☐ ELMER F. KALNY
- ☐ GERTRUDE M. COIT
- ☐ _____

FOR CITY TREASURER
(Vote for One)
- ☐ LOUIS McGINLEY
- ☐ ERNEST O. WILHELM, JR.
- ☐ _____

FOR ALDERMEN
(Vote for Eight)
- ☐ GERALD S. MAJEWSKI
- ☐ WILLIAM F. AIKEN
- ☐ ALFRED J. STRAMAGLIA
- ☐ ROBERT F. FORTELKA
- ☐ SAMUEL J. KELLEY
- ☐ EARL C. BOEHM
- ☐ ROBERT J. SCATENA
- ☐ ROBERT T. KAMPWIRTH
- ☐ JOSEPH D. CASSATA
- ☐ ROBERT COUNSELL
- ☐ HARLEY M. HANSON
- ☐ GEOFFREY OLDER
- ☐ JACK EDWARD ROME, SR.
- ☐ CONSTANCE P. SEDDON
- ☐ VACLAV J. SEVCIK
- ☐ SHEREN W. STEVENSON
- ☐ EDWIN P. UBIS
- ☐ CARL A. WESTON, JR.
- ☐ JOSEPH A. RITO
- ☐ JAMES G. PALADINO
- ☐ JON P. WEITZEL
- ☐ _____
- ☐ _____
- ☐ _____
- ☐ _____
- ☐ _____
- ☐ _____
- ☐ _____
- ☐ _____

The first election for Darien city officials was held February 21, 1970. The ballot shows the contested races for mayor, city clerk, city treasurer, and eight aldermen. Many of the individuals who had worked for incorporation continued their civic involvement. The first paid city employee was Miki Pankow, who was hired as a secretary/police matron.

Born and raised in the area, Edward Jenkins was elected as Darien's first mayor in 1970. Ed began his career as a member of the Argonne National Laboratory's fire department. He served as president of School District No. 61 from 1966 to 1969. The term of office for the first elected officials was one year.

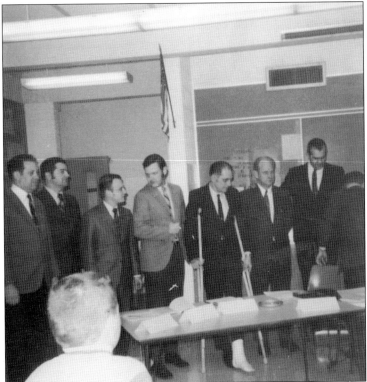

Newly elected city clerk Elmer Kalny swore the first city council into office in February 1970. From left to right are Samuel Kelley, William Aiken, Robert Kampwirth, Robert Fortelka, Gerald Majewski, Earl Boehm, and Alfred Stramaglia. Alderman Geoffrey Older was sworn in later after winning a contested election. Coincidently, in the same year that Darien's first city government took office, the Conrad Buschmann/ Fred Wehrmeister farmhouse burned, another signal that a former era was ending.

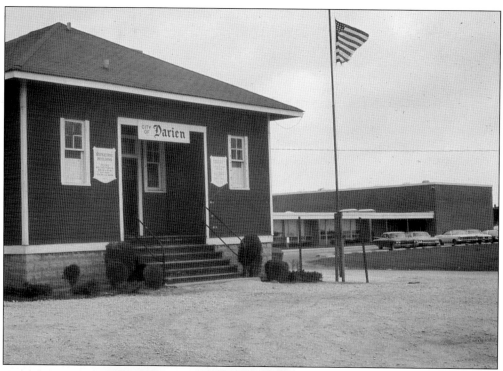

The intersection of Seventy-fifth Street and Cass Avenue was considered the hub of the city. Since School District No. 61 was no longer using the first Lace School, the new city adopted it as Darien's first city hall. A protective screen was put on the window of a small room that was used as temporary jail until those arrested could be picked up by the DuPage County sheriff. Edward Musial was the first policeman hired by Darien.

Patricia Rodgers, designer and creator of Darien's flag, puts the finishing touches on her handiwork. The background is blue, Darien's official color. Each star represents the four subdivisions that united in 1969 to become the City of Darien. In the center of the flag is the first Lace School, now known as Old Lace and home of the Darien Historical Society where the original flag proudly hangs.

LaMar and Patricia Rodgers moved to the area in 1956, and LaMar quickly got involved in the Boy Scouts and the Marion Hills Civic Association. LaMar was instrumental in forming a committee of homeowners to create a baseball club. The year 1960 saw the start of the Lace–Marion Hills Youth Club. LaMar was a charter member of the group and served as its first president.

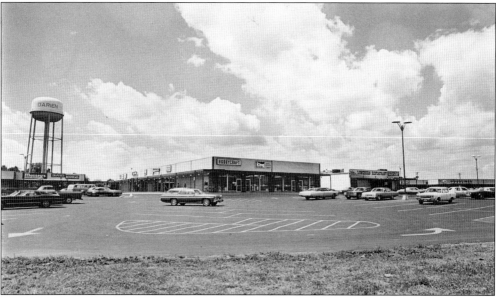

IGA was the anchor store in what grew into the Brookhaven Shopping Center that was built in two separate phases. Brookhaven Drugs and the McDonald's at "The Point" were the first commercial enterprises licensed by the city. The water tower reads "Darien," which is another sign that the city had arrived.

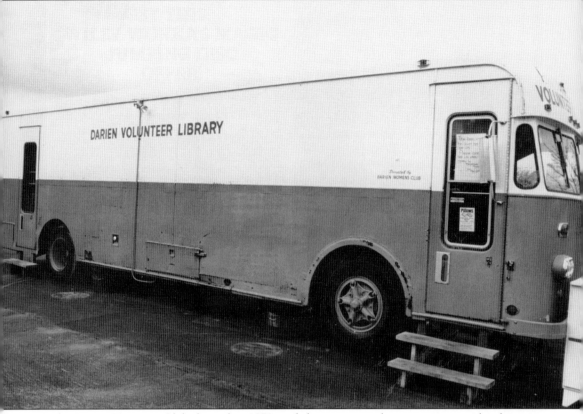

The Darien Woman's Club, formed in 1970, and the city council were instrumental in bringing the Suburban Library System bookmobile to Darien. The Darien Woman's Club raised $5,000 and the city council provided $3,100 to provide for the first year of service. Through the club's fundraising efforts, they were able to continue the service for a second year. The club eventually purchased the bookmobile to replace the leased one. This was the beginning of the club's efforts to bring a tax-supported library to Darien, fulfilling a community wish dating to the 1950s.

Eight

RESIDENTS OF RENOWN

Martin Barnaby Madden rose from obscurity as a water boy at a quarry in Lemont, Illinois, to become one of the most highly respected members of the US House of Representatives. Born in 1855 in England, Madden emigrated with his family to the United States in 1869—first to Boston, then moving to Lemont.

In 1870, he was transferred from water boy to a barge line on the Illinois and Michigan Canal. A year later, he slipped while tying up a barge and caught his foot between the barge and the canal bank. His leg had to be amputated at the knee. Rather than pursue a lawsuit, Martin's family accepted the company's offer to employ him as a clerk. Thus began a career that eventually led to Martin becoming president of the Western Stone Company in 1895.

Madden was a delegate to every Republican Party national convention from 1896 to 1924, serving as a member of the Resolutions Committee at practically every convention.

At the 1900 convention, he wrote the plank on the subject of the Central American Canal for the Republican Party platform, proposing an isthmian canal. Madden visited the Panama Canal site in 1907 and again in 1925, when he was shown possible sites for a dam to be built to create an additional water reservoir for the canal. When built, Madden Dam was named in honor of his support for the project.

Born in Chicago in 1888, the successful industrialist Erwin O. Freund developed an artificial sausage casing that could be peeled away after cooking, thus creating a skinless hot dog. He established the Visking Corporation (now Viskase Companies).

Freund and his wife, Rosalind, bought 200 acres of land in the southeastern part of DuPage County where they built a summer home in 1936. Fond of *Alice in Wonderland*, he named his estate Tulgey Wood and placed carved wooden figures of the story's characters along several miles of bark trails.

Erwin O. Freund was also president of the Jewish Children's Bureau in Chicago, now a part of Jewish Child and Family Services.

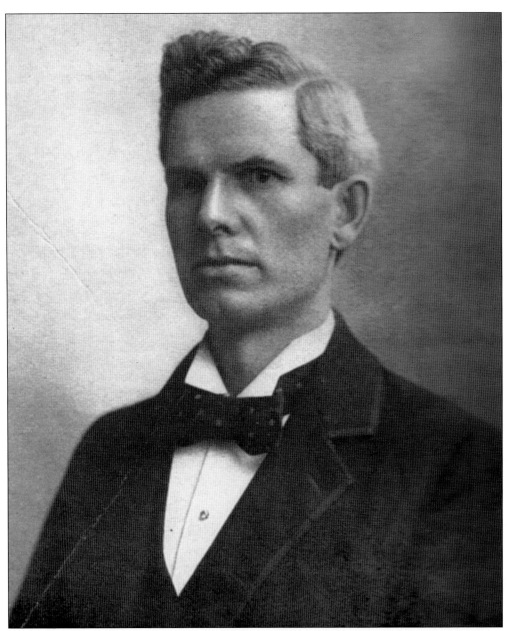

During the 1880s, Madden decided to enter Chicago politics. Elected to the Chicago City Council, he served from 1889 to 1897—four of those years as its presiding officer, including 1893, the year Chicago played host to the World's Columbian Exposition. His political career was capped when he was elected from the 1st Illinois Congressional District to the US House of Representatives, where he served from 1905 until his death in 1928 of a heart attack in the cloakroom of the Committee on Appropriations of the House of Representatives, which he chaired.

In 1878, Martin visited Elisha Smart, a prosperous farmer living in Cass, where he met Elisha's youngest daughter, Josephine. Martin and Josephine were married in 1878. A few years after their marriage, an infection damaged Josephine's hearing. Despite the best care, nothing could be done, and Josephine became deaf. Josephine is pictured with two of her five grandchildren, twins Josephine and Floranne Henderson. (Courtesy of Al Francis.)

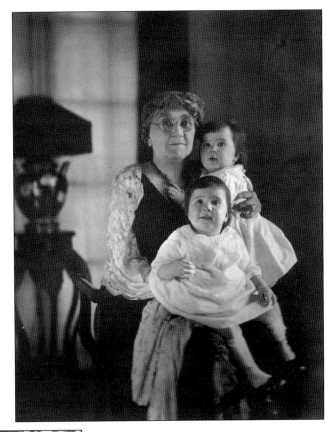

Almost 400 years old before it was felled in a storm, the Singing Oak was a favorite place for Josephine to cool herself in the summer heat. According to local lore, this is where Martin Madden first met Josephine, heard her singing, and fell in love. Numerous trees graced the Smart property, now the home of the Carmelite Spiritual Center, formerly known as Aylesford.

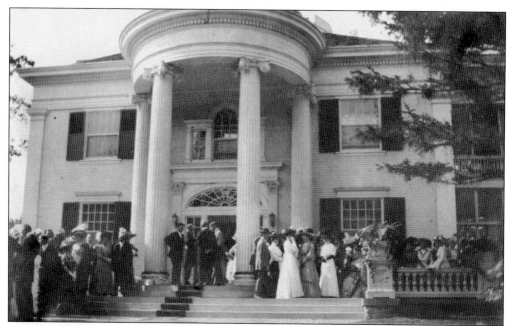

In 1903, on the site of Josephine Madden's childhood home, the Maddens built a summer home, rumored to be a 25th wedding anniversary present. Martin called it Castle Eden after a favorite childhood place in England. It was built to be a replica of the White House in Washington, DC. Their only child, Mabel, was born in 1886. In the summer of 1910, Mabel married Col. Paul Henderson, her high school sweetheart, at Castle Eden, reportedly under the Singing Oak, the same tree where her parents were married. (Courtesy of Al Francis.)

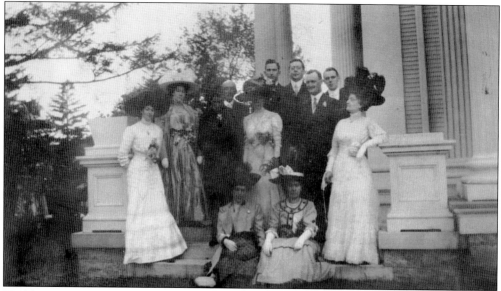

Wedding guests in their finest attire pose on the portico of Castle Eden. Malinda Andermann remembered that the Maddens had a very fancy horse-drawn carriage called Tally Ho, whose driver wore an elaborate livery. Residents waited to catch a glimpse of it as it came down Cass Avenue on the way to pick up guests at the Greggs (now Westmont) train station. (Courtesy of Al Francis.)

Born in 1884, Col. Paul Henderson grew up in Chicago and, in 1907, started working at the Western Stone Company, rising from salesman to succeed his father-in-law as president. In 1917, he served in the US Army in France in World War I. Remaining in the Army after the war, he reached the rank of colonel in the Army Air Services. President Harding appointed him second assistant postmaster general in 1922 where he devoted much of his time to the airmail service (CAM flights), dramatically improving its safety record through the use of enormous lights. Resigning his post in 1925, Henderson became the general manager of National Air Transport, which became the nation's leading carrier of airmail when the federal government privatized the service. (Courtesy of Nathaniel L. Dewell Collection, National Air and Space Museum [NASM 00128496], Smithsonian Institution.)

Congressman Madden and his daughter, Mabel, were among the prominent first cabin passengers aboard the SS *Leviathan* of the US Lines as Capt. Herbert Hartley steered what was then the world's largest ocean liner from New York across the Atlantic on Independence Day 1923. The *Leviathan* was a converted World War I troop carrier. At left are Madden and his daughter, Mabel, on the deck of the ship. In the picture below, Madden on the far right is standing next to Captain Hartley, often referred to as Commodore Hartley. (Both, courtesy of Al Francis.)

The Madden family members gather outside Castle Eden. Madden had five grandchildren, whom he adored. Pictured are, from left to right, Josephine Madden, her sister Emma Cecelia Warden, Emma's daughter Minnie Toolen, Martin Madden, Alice Leonard Olson, and Mabel Henderson, along with Mabel's twins, Josephine and Floranne Henderson. (Courtesy of Al Francis.)

Martin Madden's stature was confirmed when the fighting "watchdog of the treasury" was accorded a funeral in the House of Representatives chamber in 1928. President Coolidge, his cabinet members, Vice Pres. Charles Dawes, members of the Senate, Chief Justice William Taft, and most of the diplomatic corps attended the service. Vice President Dawes gave the eulogy. The chaplain of the House of Representatives traveled to Castle Eden to give the eulogy at the funeral service there. Martin Madden was buried in the Cass Cemetery about which he once said, "It's a lovely spot . . . and isn't it nice to think that I shall lie out there." Josephine died in 1934 and is buried alongside him.

The land and home remained part of the Madden estate until 1952. Louis Petermann (pictured) was the son of John Petermann and the father of Ann Dedic of the Dedic Pumpkin Patch (see chapter six). John was Madden's friend who worked with him carrying water for mules that towed barges along the Illinois and Michigan Canal. John became caretaker of Castle Eden in 1909. In 1922, Madden insisted that John accept a partnership in the farm. The Petermann family lived in Castle Eden from 1942 until 1950. (Courtesy of Joel Dedic.)

During the late 1930s until 1942, the Thayer family rented Castle Eden and opened a restaurant. This venture ended with the onset of World War II and gas rationing. In 1959, the Carmelites purchased Castle Eden for the present-day Carmelite Spiritual Center, formerly Aylesford. The stable and coach house were remodeled into Pilgrim Hall, which house a chapel, dining hall, and meeting rooms.

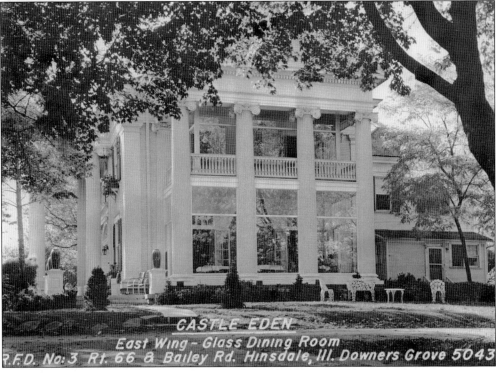

Holidays were significant events at Erwin and Rosalind Freund's Tulgey Wood estate. Perfect for casual hospitality, the home often saw 40 to 60 guests gathered for Thanksgiving dinner, dining on not one but three 25-pound birds, like the one Erwin is carving. (Courtesy of Janet Freund.)

The heart of Freund's gray-shingle, air-conditioned home was a 24-by-48-foot wood-paneled living room with a massive stone fireplace and vaulted beamed ceiling. The place was furnished in Early American, and the walls held originals of the illustrations from the first editions of Lewis Carroll's books. When the federal government acquired Freund's property in 1946 and established Argonne National Laboratory on the site, Freund's home became Freund Lodge.

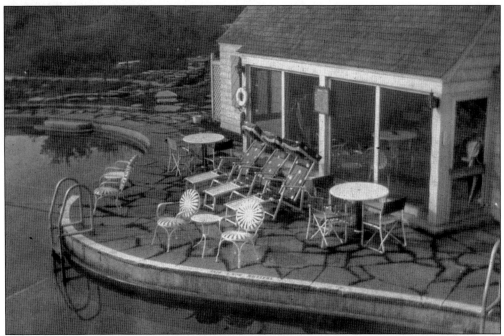

Over time, the estate reflected more and more of the Freunds' interests and hobbies. It had numerous amenities including a tennis court, a screened picnic pavilion, and a pool and bathhouse. Small replicas of hot dogs hung from the pool ropes. The pool remains on the site of Argonne National Laboratory.

Freund and his wife were skeet-shooting enthusiasts. To accommodate their enjoyment of this sport, this skeet-shooting field, named Fort Roz, was built northwest of the swimming pool. There were shooting parties for 35 or more people followed by barbecues. A Quonset hut on the property housed Freund's model railroad complex that filled a 20-by-60-foot area and was operated from push-button controls on the balcony.

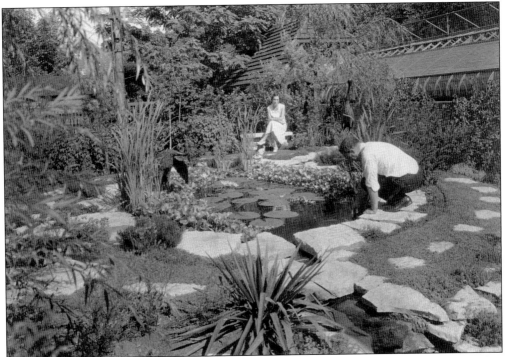

Rosalind and Erwin enjoy the water garden in front of the entrance to their home. The garden was the center of a series of concentric gardens containing plants, many of which were grown on the estate. Arriving guests were treated to this lush, tropical-looking scene. (Courtesy of Janet Freund.)

Freund's interest in growing orchids evolved from a venture of growing cucumbers and tomatoes hydroponically. He returned from travels with orchids from all over the world. The plant collection grew to fill three greenhouses. Freund designed the greenhouses to include an automatic humidifier, large tanks for mixing plant food, and pipes to carry food to the plants. He also added an automatic plant potter that could plant up to 200 plants a day.

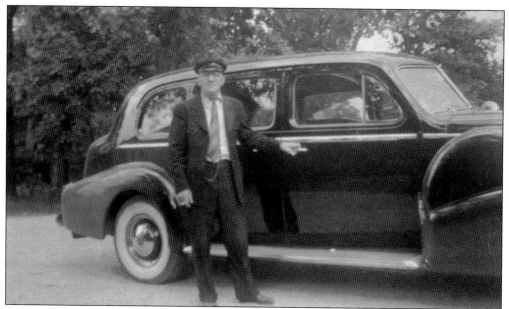

The Freunds were fond of the opera and attended many performances in Chicago, being driven by their chauffeur in their 1940 Cadillac Fleetwood. The estate staff, treated as part of the family, lived in housing on the property. When Freund died in 1947, his kennel man, Robert Rogers, wrote that Freund "was never a boss; he was a friend and counselor."

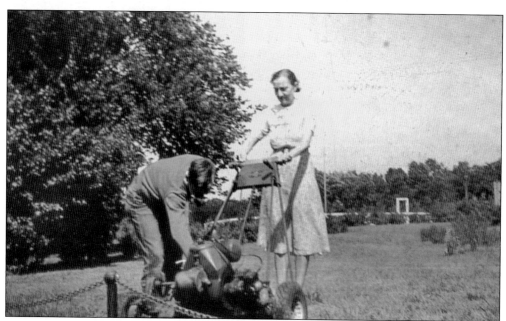

Unusual for the 1930s, the Freund estate had an underground sprinkler system and a power lawn mower.

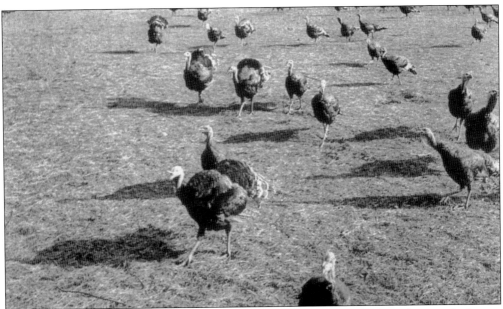

For a while, the Freunds had two chimpanzees who were occasionally brought into the house. Chickens and sheep were a familiar sight, and a peacock strutted and preened throughout the property. Turkeys that were raised "above ground," a new science at the time, were banded with a Tulgey Wood label and sold.

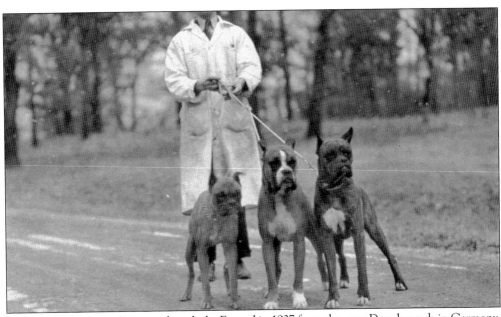

Boxer dog Lustig vom Dom was bought by Freund in 1937 from the vom Dom kennels in Germany. Lustig, along with four sires all imported from Germany in the 1930s, were the progenitors of the American Boxer. Lustig vom Dom sired 41 champions for Tulgey Wood Kennels. While the names of these dogs are not known, they were part of a continuous population of nearly 70 show-quality boxer dogs.

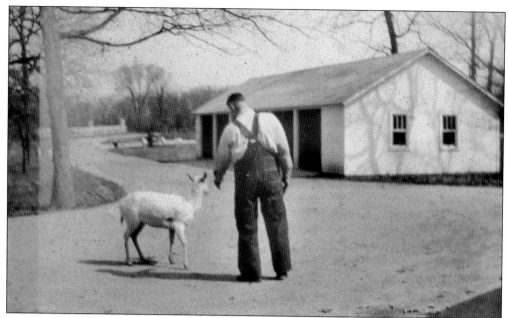

In 1941, Freund acquired less than 10 fallow deer (*Dama dama*) from clothier and friend Maurice L. Rothschild. On Rothschild's estate in Highland Park, the deer had to be kept penned against their nature and his. Fallow deer are native to North Africa, Europe, and parts of Asia. Born creamy tan with white spots, they turn completely white when they are a year old. The deer became very tame, like this one seen with Louis Rediehs, Freund's caretaker.

Sawmill Creek meandered through the estate, much of which was left in its natural state. A wooden bridge over the creek was most likely built atop limestone from nearby quarries. Between 1946 and 1949, the federal government acquired almost 150 properties amounting to over 3,600 acres as the site for Argonne National Laboratory. Limestone remnants of structures that were relocated can be seen in Waterfall Glen (which includes the former Rocky Glen) Forest Preserve, surplus land purchased by the DuPage County Forest Preserve.

Artificial lakes were made in Tulgey Wood, creating recreational opportunities for Freund's employees during the winter and summer months. Above, Mary Rediehs, wife of Louis, is standing atop a limestone wall and watching fellow staff members enjoy a leisurely canoe ride. Mary's son Erwin is in the front of the canoe. Below, Mary is on the bottom of the sled as Erwin pushes it over the frozen lake.

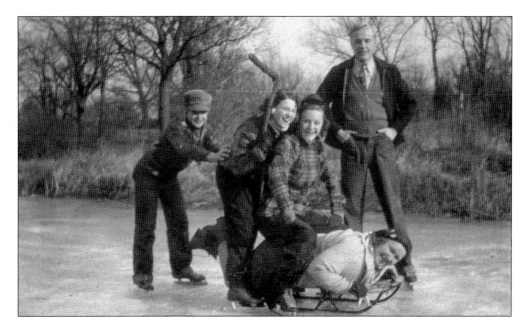

Photographs like these of Tweedledee and Tweedledum do not do justice to the remarkable *Alice in Wonderland* wooden figures Freund placed in various locations throughout his estate. Unfortunately, they no longer exist. Erwin Freund suffered a heart attack in his office and passed away in 1947, one year after losing his beloved Tulgey Wood. (Courtesy of Janet Freund.)

In the late 1950s, during the height of the Cold War following World War II, the federal government began installing Nike air defense missiles in sites throughout the country. Three Nike launch sites were placed in the vicinity of Argonne National Laboratory along Ninety-first Street. By the 1970s, they were rendered obsolete, and the launch sites were decommissioned and dismantled.

Today, the former first Lace School is the home of the Darien Historical Society Schoolhouse and Museum. Its artifacts are testimony to the past in the hope that those who come after will preserve them for the future.

Discover Thousands of Local History Books
Featuring Millions of Vintage Images

Arcadia Publishing, the leading local history publisher in the United States, is committed to making history accessible and meaningful through publishing books that celebrate and preserve the heritage of America's people and places.

Find more books like this at
www.arcadiapublishing.com

Search for your hometown history, your old stomping grounds, and even your favorite sports team.

Consistent with our mission to preserve history on a local level, this book was printed in South Carolina on American-made paper and manufactured entirely in the United States. Products carrying the accredited Forest Stewardship Council (FSC) label are printed on 100 percent FSC-certified paper.